Leah Day's

GODDESS QUILTS

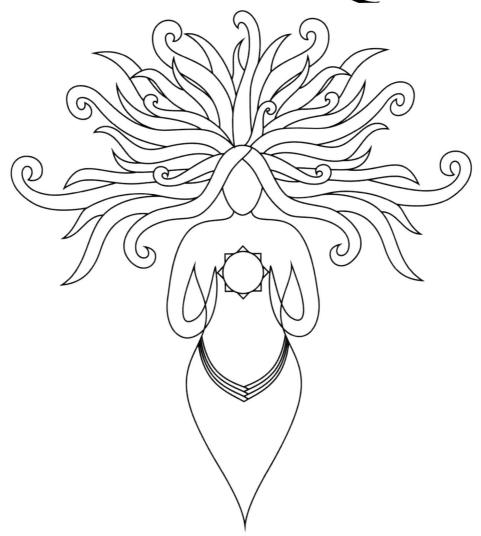

JOURNEY INTO LIGHT AND LOVE
THROUGH ART QUILTING

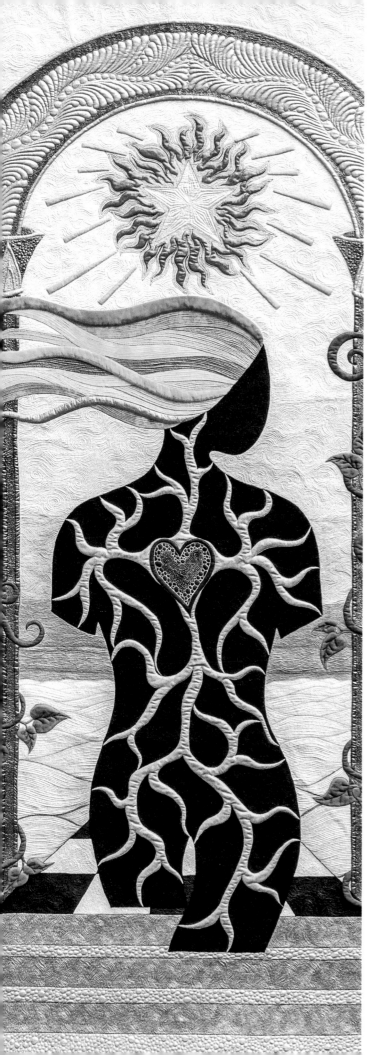

Leah Day's Goddess Quilts: Journey into Love and Light Through Art Quilting

Copyright © 2019 Leah Day

Day Style Designs
P.O. Box 386
Earl, NC 28038

Email: Support@DayStyleDesigns.com
www.LeahDay.com

Artwork and Photography by Leah Day

Additional photography by:
F. Gray - Family photo (page 13)
Paul Huggins - The Duchess (page 54)
James Day - Building blocks and Leah Day (page 68 and 95)

ISBN: 978-1-951504-00-7

Printed in the United States of America

Large print, audio and ebook versions of this book can be found at ~ **LeahDay.com/Goddess**

Leah Day's
GODDESS QUILTS

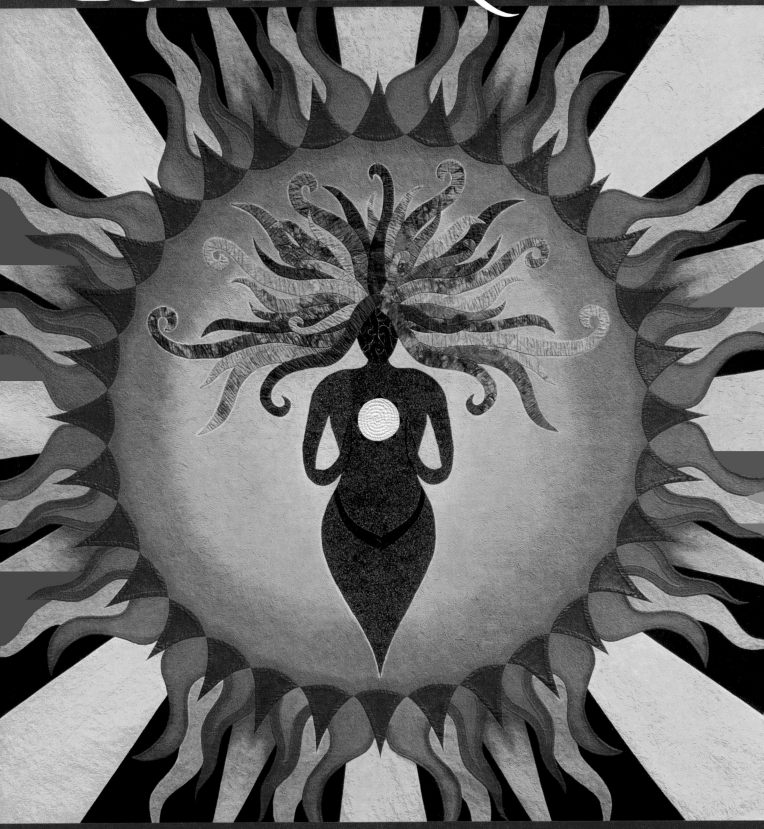

JOURNEY INTO LIGHT AND LOVE
THROUGH ART QUILTING

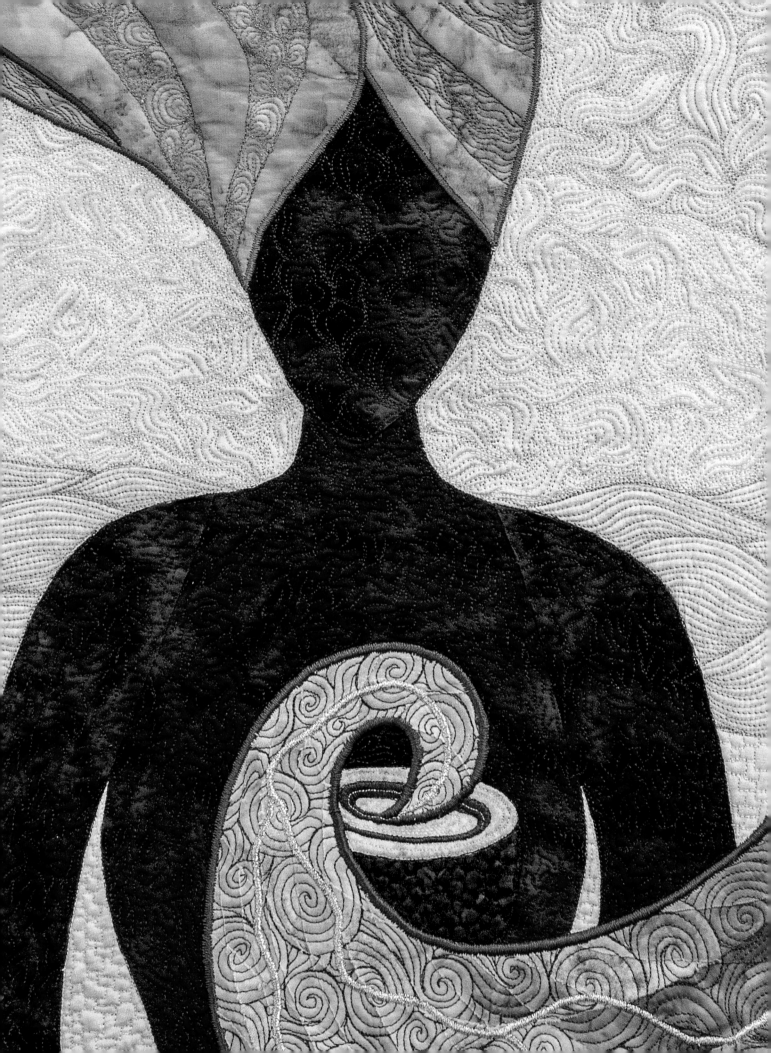

Dedication

For my son, James. I have made many things,
but nothing as awesome as you.

And to our future children, if we should be so blessed.

Acknowledgments

I've been making quilts for fourteen years and I have many people to thank for starting me on this journey.

Thank you to my grandmothers and great grandmothers for making quilts and passing them down to my parents. All my favorite childhood memories include your quilts. I spread them on the ground for picnics, draped them over chairs to build forts, and snuggled under them in bed every night.

Thank you to my parents for sharing your love of craft and respect for handwork. I'm so happy you didn't replace our broken TV for most of my childhood. I don't think I'd be a quilter today if you had.

Thank you to my sisters for your love and patience and the joy your children have brought to our lives.

A special thank you to the quilting teachers who taught and inspired me: Karen McTavish, Dottie Moore, Robbi Joy Eklow, Ann Holmes, Sally Collins, Linda Cantrell, Irena Bluhm, and Nancy Zieman.

Big hugs and boxes of chocolates for my friends Anne and Kati. Your support and kindness carried me through this journey.

My goddess quilts and this book wouldn't exist without my husband Josh. Your patience, understanding and occasional butt kicking kept me focused, even when things got tough. Thank you for sharing your life with me.

Here's a big, sloppy embarrassing kiss for my son James, who kept me fueled with chocolate chip cookies and coffee while writing. I love you more every day.

More books by Leah Day

Dream Goddess ~ 3 Month Planner and Creativity Journal

Mally the Maker and the Queen in the Quilt

Explore Walking Foot Quilting with Leah Day

365 Free Motion Quilting Designs

365 Quilting Designs Perpetual Calendar

How to Piece Perfect Quilts

Free Motion Quilting from Feathers to Flames

Free Motion Quilting from Daisy to Paisley

CONTENTS

INTRODUCTION 3

PART 1 ~ EMBRACE ~ 8

CHANGE 10
CREATIVITY 16
GRATITUDE 26

PART 2 ~ OVERCOME ~ 32

NEGATIVITY 34
PAST PAIN 40
GRIEF 46
FEAR 50
EGO 54

PART 3 ~ CHOOSE ~ 64

FORGIVENESS 66
COURAGE 76
ACCEPTANCE 84

INTRODUCTION
WHY GODDESS QUILTS?

I drew my first goddess in high school. Bead work and cross stitch were my crafts at that time so I designed this Mother Earth figure on graph paper, coloring in the boxes to represent tiny seed beads or square stitches.

I felt something different when I looked at this drawing. Her shape pulled at my mind and pushed at my heart in an unexpected way.

The cross stitch I began from this design meant more to me than anything else I'd ever made. Even though the piece wasn't finished, I kept her safe for over fifteen years, through multiple moves in college, to my first apartment, and finally to the home I share with my husband Josh.

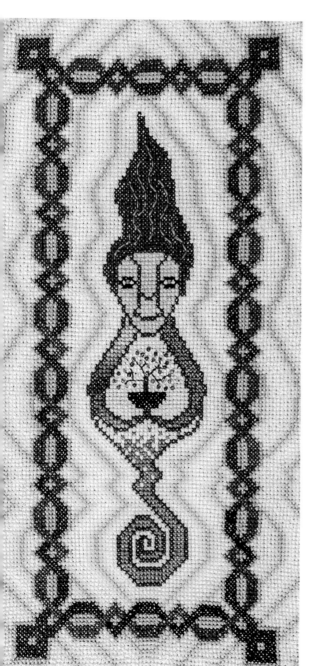

I saved this piece even after I became a quilter and set my beads and embroidery floss aside. I didn't know how to finish this project, but I couldn't throw her away. She was too special.

I remembered the power of drawing that goddess when I was pregnant with my son. I'd been quilting for two years and had made many traditional patchwork quilts.

Making these quilts had kept my hands busy, but their simple geometric shapes held very little meaning to me personally.

That's not to say I didn't love patchwork quilts. I'd wanted to learn how to cut intricate pieces and sew them together since I was a little girl. A big reason why I became a quilter was to make soft blankets and cuddly throws for my family.

But I wanted more out of quilting. I wanted to make quilts with deeper meaning that would transform my life just as my hands transformed the fabrics. I found what I was looking for when I made my first goddess quilt, Life and Fire.

After sketching the design, I felt that same pull on my mind and push on my heart. I knew I was doing more than stitching pieces of fabric together, I was stitching myself together.

Making these quilts became my vehicle for change and self discovery. Each quilt in this series has turned me inside out and upside down and helped me transform from the weak girl I was to the strong woman I strive to be.

I felt more alive as I made these quilts and they changed my life in every way possible. So quite simply - I make goddess quilts because they are what my heart most needs to create.

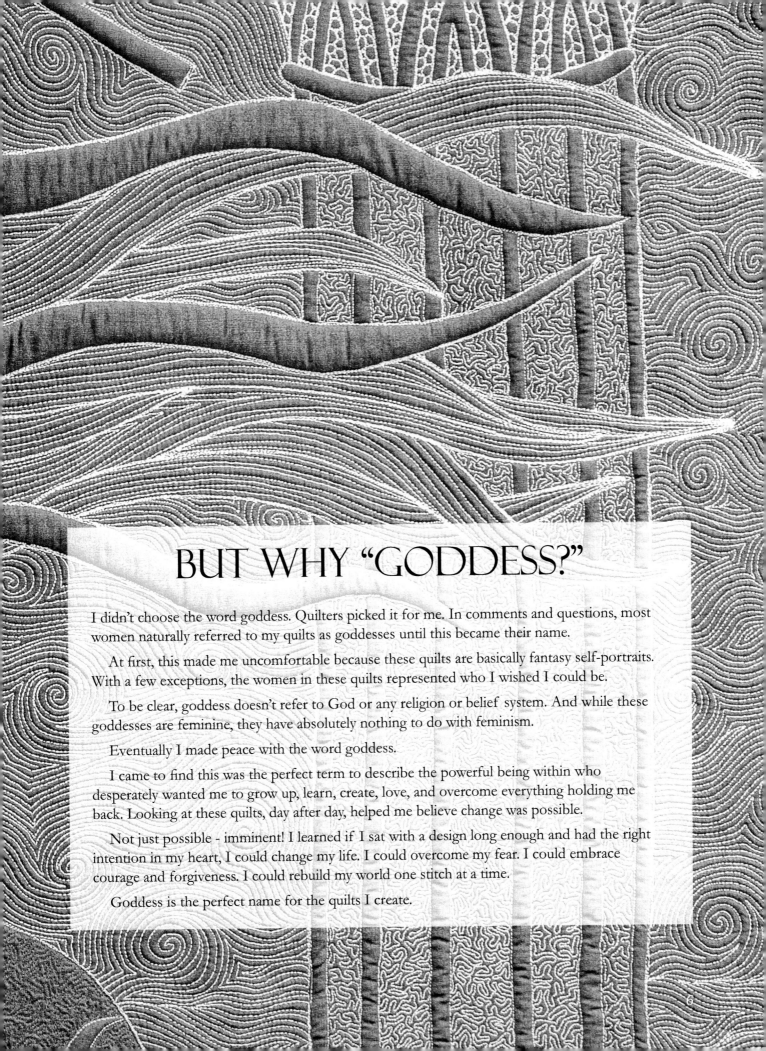

BUT WHY "GODDESS?"

I didn't choose the word goddess. Quilters picked it for me. In comments and questions, most women naturally referred to my quilts as goddesses until this became their name.

At first, this made me uncomfortable because these quilts are basically fantasy self-portraits. With a few exceptions, the women in these quilts represented who I wished I could be.

To be clear, goddess doesn't refer to God or any religion or belief system. And while these goddesses are feminine, they have absolutely nothing to do with feminism.

Eventually I made peace with the word goddess.

I came to find this was the perfect term to describe the powerful being within who desperately wanted me to grow up, learn, create, love, and overcome everything holding me back. Looking at these quilts, day after day, helped me believe change was possible.

Not just possible - imminent! I learned if I sat with a design long enough and had the right intention in my heart, I could change my life. I could overcome my fear. I could embrace courage and forgiveness. I could rebuild my world one stitch at a time.

Goddess is the perfect name for the quilts I create.

~ PART 1 ~
EMBRACE

I believe the greatest challenge in life is choosing to feel satisfied and content.

The first three goddess quilts I created helped me embrace change, my creativity, and the abundant gratitude that makes life worth living.

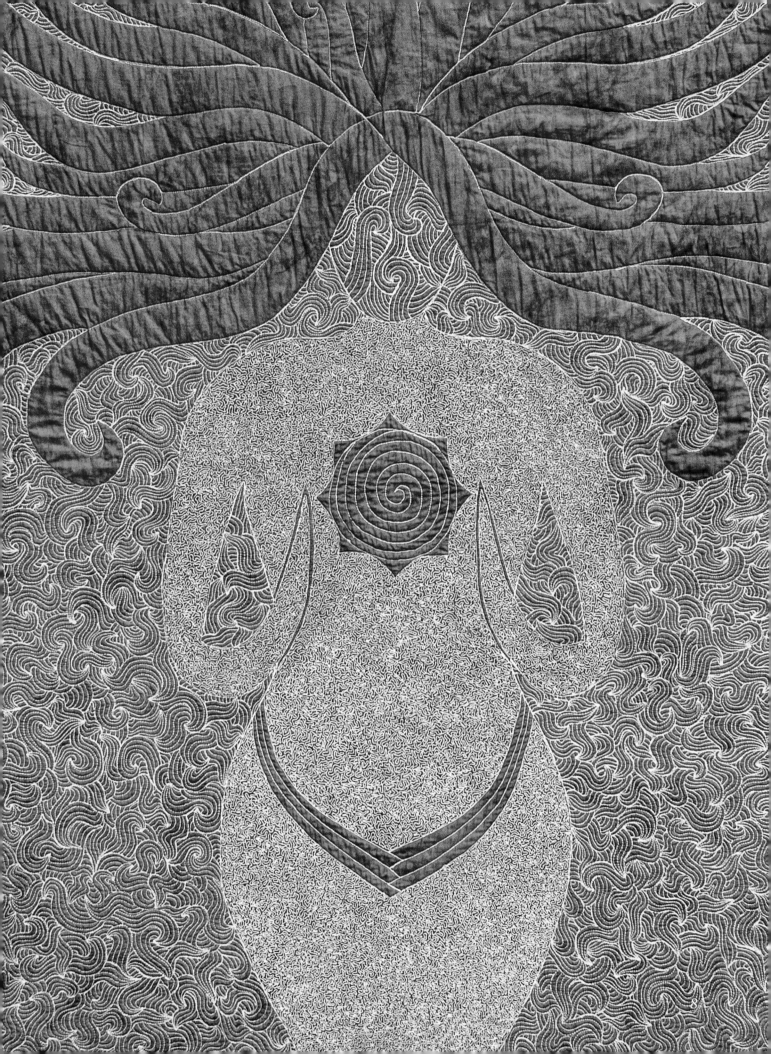

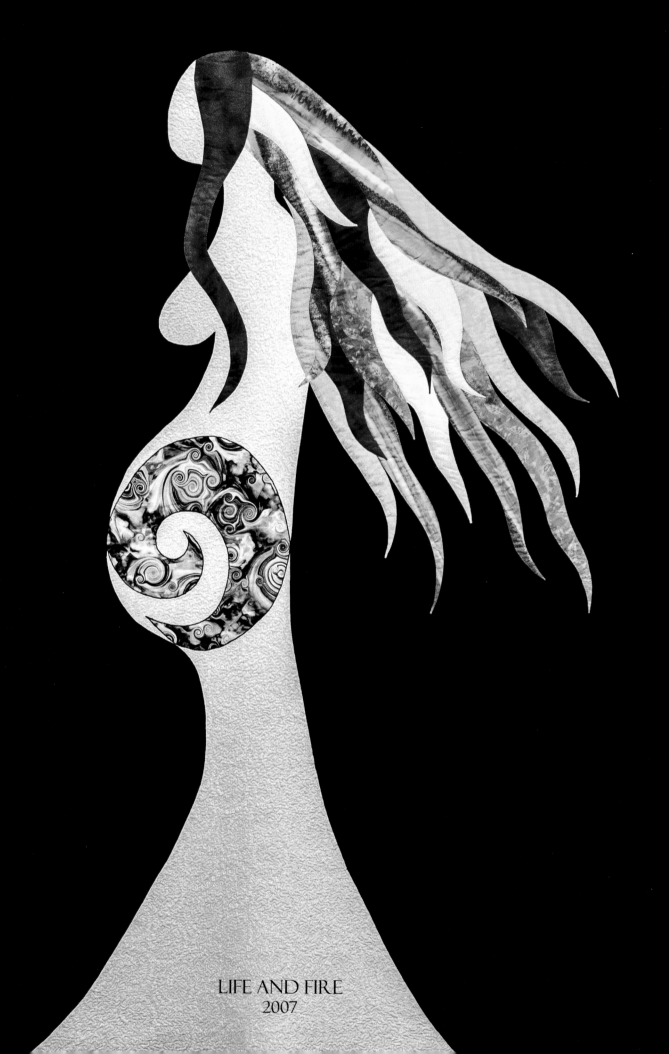

LIFE AND FIRE
2007

CHANGE

I wanted to have a baby for more than a year before I got pregnant. Josh and I had just gotten married and were living in a tiny apartment that didn't allow children. We'd have to move before we could start a family and in many ways this felt like waiting for my real life to begin.

I was miserable. I'd dropped out of college to start a creative business but had ended up taking the first job that had come my way, sewing fifty plus-sized garments a week. My day started at 6 am and often stretched well into the evening, leaving no time to hang out with Josh or pursue my entrepreneurial dreams.

I spent the little free time I had researching pregnancy and childbirth. Being the youngest in my family, I didn't know much about babies, and I'd never learned anything about childbirth in school. I read every baby book I could find, then went online to learn more. I couldn't wait to become a mother.

Consequently, when I got pregnant and we bought our first house, childbirth was the only thing on my mind. Five months into my pregnancy, I stopped sleeping. I'd lay in bed, staring at the ceiling while my mind spun in excited circles.

I was filled with a strange combination of anticipation and anxiety. I couldn't wait to give birth, but I was also afraid I wouldn't be able to handle the intensity of labor. These conflicting emotions refused to let me rest.

I spent many long nights piecing log cabin quilt blocks while Josh slept. I rattled around the house, my belly growing bigger and my mind more restless every day.

Then one night out of the blue, I fell asleep.

In a dream, I saw this powerful figure: a beautiful pregnant woman standing strong, her fiery hair blazing with power.

She embodied everything I wished I could feel and I instantly wanted to make her into a quilt.

I started drawing the next day. As I finished her flowing hair, I realized I'd forgotten to give her arms. I sketched a bit to test the idea, but immediately erased the lines. No matter where I put her arms, I didn't like them.

I asked for Josh's opinion. He always looked for the simplest solution and never minced words.

"No, of course she doesn't need arms," he said. "That would cover up her belly. Keep going. I can't wait to see this quilt."

I was excited too. In the days since I'd started working on her, I'd slept better. I constructed the quilt top on our kitchen table, the only flat surface in our house big enough to hold the design.

Thankfully the large appliqués fit together easily, and it only took a few days to glue all the pieces together. Josh was willing to eat dinner on the floor once or twice, but would put his foot down if I hogged the table for too many nights in a row.

It was a relief to see the design in my head become a reality. This goddess was the perfect symbol of strength and courage for the childbirth soon to come.

The quilt top had come together easily, but this project was far from complete. After layering the top with batting and backing fabric, I set to work zigzag stitching around the appliqué shapes.

Then I quilted the woman's body densely with white thread. I'd thought stitching the design this way would make the quilt more beautiful.

I filled the dark background with simple curving lines. Unfortunately, this wasn't enough quilting to balance the dense stitching in the woman's body.

The first time I hung this quilt on a wall, I almost cried. She hung terribly.

The goddess's body flared out from the wall, creating a dramatic ripple across the bottom edge. I stared at the effect, completely at a loss. I didn't know what I'd done wrong, only that it looked awful.

I was so disappointed. I'd wanted to create a symbol of strength and beauty, but I'd ended up with a quilt that showcased my lack of skill instead.

BLESSING OF TIME

Little did I know this would be a pattern for almost all my goddess quilts. Every single one of them presented challenges that pushed the limits of what I understood about quilting.

Most of my goddess quilts were a disappointment when hung on the wall for the first time. Sometimes this feeling was so overwhelming I had to put the quilt away for a little while.

But no matter how much I hated a goddess when it was finished, time always changed my perspective. In as little as six months, I could look at her again and smile. That break gave me time to grow and be able to appreciate the skill I had when I made her.

Yes, this goddess quilt had flaws. I had less than two years of quilting experience when I started this project. All the quilts I made during this time had flaws. That I was able to make her at all was an amazing accomplishment.

The ability to look at my past work with compassion is one of the greatest gifts this goddess series has given me.

FROM WOMAN TO MOTHER

When designing this pregnant goddess, I'd tried sketching a realistic baby shape in the woman's belly. My lack of drawing skills quickly ruled that out, so I used a large spiral instead.

This symbol ended up being the perfect choice because my son was a total mystery to me until the moment he was born. I knew I was having a baby, of course, but I hadn't quite wrapped my head around exactly what that meant.

When James emerged from my body, I reached down, and the moment our skin touched, my world shifted forever. I suddenly understood - this is another person.

Another person.

Another human being separate from me, but still inside me. Only in the last minute of my pregnancy I realized what an awesome blessing that time had been. I'd carried my son for that brief time, and we would *never* be that close again.

Everything went still. For a few glorious moments I was wrapped in a sense of peace so intense it was like I left this universe behind.

I was surrounded with light and love. All the pain and fear and stress of labor melted away. It was like death metal music had been blaring in my head my whole life and it was suddenly clicked off.

I was in Heaven.

I've even wondered if I died for a short time that day. I remember feeling like the barriers between life and death were thinner in that moment and I could have easily slipped away. I desperately wanted to stay there, just a moment longer, just a bit more time, *please.*

But then Josh's voice broke through the silence, telling me to push. He brought me back to reality and together we gave birth to our son.

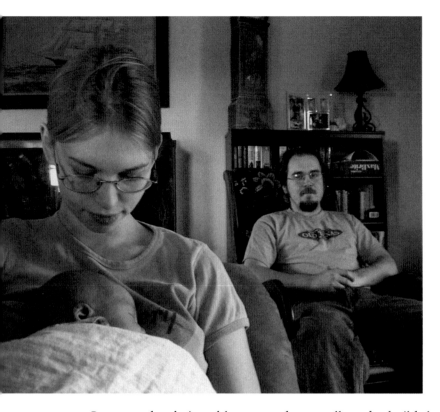

I wish I could say James' birth was everything I'd built it up to be. I expected to have a supercharged moment of intense love with my husband and child.

That didn't happen for me; it happened for Josh instead.

He broke down cradling his new son to his chest while I sat back on my heels and wished with all my heart I could travel back in time and have another minute in Heaven.

I couldn't shake the feeling of loss. That peaceful place had been yanked away and I was left bruised and broken on my bedroom floor, struggling to wrap my brain around what I'd experienced.

Over the next few days, that sense of loss only increased. In one evening, I'd lost my mind, my body, and my strength.

I was used to being able to tear down walls and rebuild them in a day. Now I could barely pick up my new baby. This was a level of weakness I'd never expected to feel.

This massive change wouldn't have been as traumatic if I'd had more support. In my research on pregnancy, I'd learned about unassisted childbirth. I'd decided to give birth at home, with no doctor, nurse, or midwife attending. I believed this was the safest, most natural way to give birth.

But this decision cost me dearly. I had no support or advice in those first chaotic days. I eventually decided to go to the hospital to get an IV and check that my body was healing properly.

What followed was the most painful, humiliating experience of my life. The emergency room staff had no idea what to think of us. The gynecologist who treated me was judgmental and confusing. As we were leaving a nurse informed us that Child Protective Services would be contacted to review our case. The message was clear – you're crazy and stupid and not fit to be a parent.

I returned home, my body fixed well enough on the outside, but completely broken on the inside. I believed someone from CPS would arrive at any minute to take my baby away. I cradled James in my arms and started sobbing.

I didn't stop crying for six months.

Every day I broke down like I was breaking in half. Looking back, I think a good chunk of that sadness was mourning. The girl I'd been for twenty-three years was gone. I was a mother now. I was a completely different person.

I'd wanted this change. I'd been looking forward to it for *years*. But I was unprepared to feel like every cell of my body had been transformed. I felt like a stranger in my own body. Even the thoughts in my mind seemed alien.

Josh tried to help as much as he could. I'd never needed him in this way before. But it honestly didn't matter how many hours he sat next to me, it was never enough.

That was the thing about that depression. No matter how close anyone sat to me, and no matter how many hours they held my hand, I was still alone.

The only time I felt the slightest bit of peace was when I was staring down at my tiny baby. I spent hours and hours gazing at my son, the most marvelous thing I'd ever created.

EMBRACING CHANGE

I remember the day I finally had enough of crying. I was taking a bath in the evening and realized I hadn't cried yet that day. Before I knew it, I was bent double, gasping for breath between sobs. I couldn't think about crying without crying.

It was so ridiculous, I started laughing. My giggles echoed around the bathroom while tears streamed down my face. In that moment, I felt something shift in my heart and I knew the worst was over.

That was the moment I stopped fighting against the change. I unclenched my arms and embraced my new life.

It was a big adjustment. I had a new mind, body, and will to live and succeed that I'd never had before. The second I laid eyes on James, I was filled with a fierce determination to become someone he could be proud of.

Gone was the powerless girl I'd been my whole life. I could never think of myself as weak again. But I didn't learn how to believe in myself because of the way I gave birth.

It was emerging from postpartum depression that revealed my true strength. I had to live through the regret and fear and shame of my choices. I had to make peace with myself and my decisions. I had to embrace the changes I'd gone through and accept my new life as a mother.

About six months after James was born, I hung my first goddess quilt back on the wall in the living room. Enough time had passed that I could forgive my quilting mistakes and enjoy seeing her every day, even though she didn't hang straight.

I picked a name for her, Life and Fire, for the two powerful forces represented in this quilt. I loved looking at her because she was the only goddess I made before my son was born.

Before *I* was born.

Everything I am emerged as I gave birth to my son. I had to go through that total transformation before my real life could begin. I was meant to be a mother.

This experience was challenging and scary, but I have no regrets about how I gave birth. I researched pregnancy and childbirth obsessively for years and I did what I thought was right.

I know, no matter which way it happens, whether it's in a hospital or at home and no matter how many people are there, bringing a new child into this world is a serious, life-changing experience. So much hangs in the balance and so much can go wrong that will challenge a family forever.

We owe it to our children to do everything we can to learn and prepare for the day they arrive. I believe birth is the most important, most sacred moment in a person's life and I refused to carelessly assume safety could only be found in a hospital. Babies and mothers die there every day.

As for James' birth, it was amazing. I went to Heaven. I felt the peace and stillness of God's embrace. I found my strength and became who I was meant to be. It was *awesome* in every way.

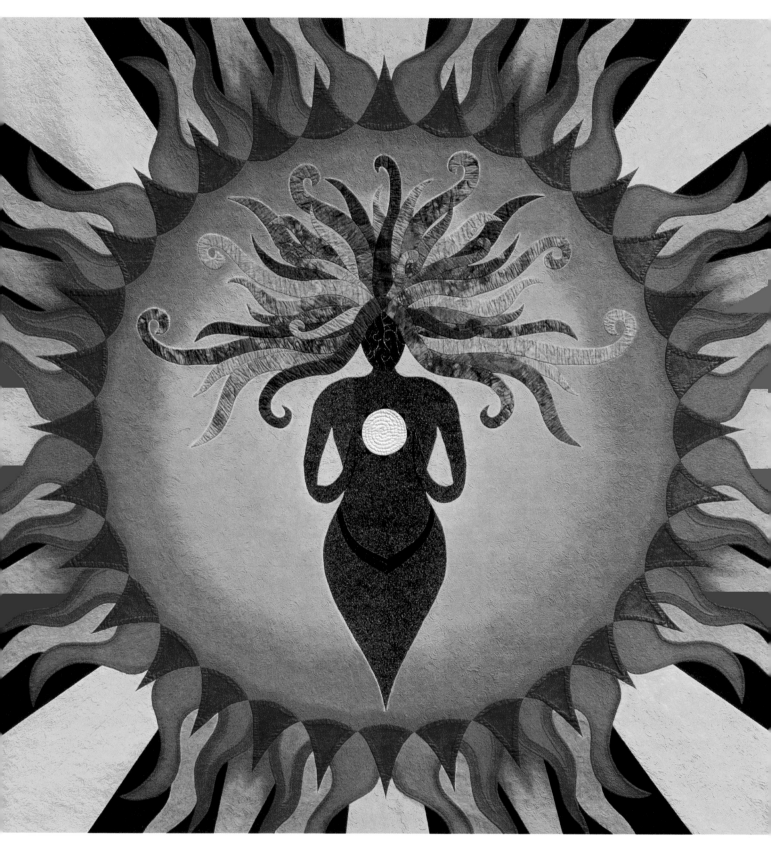

RELEASE YOUR LIGHT
2009

CREATIVITY

I started my first creative business when I was seven years old. A woman from church taught me how to fold origami boxes and I was soon selling them to my classmates for a few cents each. I kept all the nickels and dimes I'd earned in my pink Hello Kitty pencil box.

I can still remember the day I opened the box and counted the coins. I couldn't believe it. I'd sold enough boxes to buy pizza AND ice cream. For a kid who packed a cold turkey sandwich every day of the week, this was a life-changing moment.

Since that day I wanted to own a business and sell things I made. I believed in my creativity at that time. I trusted it could support me.

Unfortunately, adults have a funny way of beating down the dreams of seven year old kids. Every time I shared my dreams with someone, I got the same reaction. A condescending smile and the blunt opinion, "You can't possibly make a living with crafts."

I put my faith in education and went to college for a degree in biology. I wasn't particularly passionate about science, but my dad had always wanted me to become a doctor. Luckily a mutual college friend introduced me to Josh Day and this special guy changed the course of my life completely.

We got engaged and moved into a tiny apartment together. Josh started working online while I began my third year in college. Seeing Josh work from home every day made me think about the life I was working towards. Did I really want to get this degree? Was I willing to spend several more years in college to become a doctor?

This forced me to think long and hard about what I wanted from my life. After careful deliberation, I set my eye on this simple goal: I wanted to work from home with my husband and make a living on my own terms.

I dropped out of college the next day.

That was the first step to living the life of my dreams, but that step was just the beginning of a much longer journey. It took James' birth and my transformation into a mother before I could continue down this path.

I was ready for the next step when James was around six months old. In between nap time and meals, I designed my first website to sell a line of skin care products. Josh and I shared a basement office and James grew from a baby to a toddler playing on the floor between us.

This was exactly the life I'd wanted, but I still wasn't satisfied. Skin care wasn't creative. I wanted to build a quilting business, but how in the world would I make a living with *that*? Skin care seemed like a much more practical option. I even considered going back to college to become a licensed esthetician.

But I couldn't shake my dream for a creative business. It was like a constant toothache. One night after writing a lengthy journal entry filled with wishes and wants, I tried visualizing my creativity. I saw it as a bright light trapped in my heart.

This is what is inside me. I thought, awestruck at the sudden rush of heat over my skin. *How do I release it? How do I let my creativity out?*

That's when I saw her: A goddess exploding in the light of her creativity.

I jumped out of bed and grabbed a sheet of paper. My hands shook as I sketched a rough female form, some wild hair, and a blazing sun exploding off the edges of the paper. I suddenly saw the power of my creativity. It was like the sun – a brilliant explosion of light bigger than I'd ever imagined.

I didn't get much sleep that night. Just like with Life and Fire, the second I saw this goddess design, I had to begin making it.

I set to work cutting out the pieces for the goddess's body and hair. I picked hand appliqué and it took months to stitch the pieces in place. To save time, I decided not to appliqué the many flame shapes, but to create those details with fabric paints after the quilt was quilted.

By this point I'd realized Life and Fire hung badly because the background didn't have enough quilting. I knew I had to quilt the designs consistently to ensure this goddess quilt hung beautifully on the wall.

The first few days flew past, but very soon I realized my quilting plan had a major flaw - it was excruciatingly boring. Practically every inch of the quilt was stitched on a tiny scale. This meant very slow, very small repetitive movements as I slid the quilt through my home sewing machine.

I couldn't speed up this quilting time, so I decided to spend it wisely. As I stitched the repetitive shapes, I thought about my life and the creative business I'd wanted to start for years.

In 2009, blogging was the best way to build traffic online. I'd tried it before, but I hadn't been successful because I couldn't figure out how to share something new every day. Most of my quilts took months to create. I couldn't write about the same thing every day without boring my readers to tears.

As I began quilting the second row of flames, this goddess quilt gave me an idea.

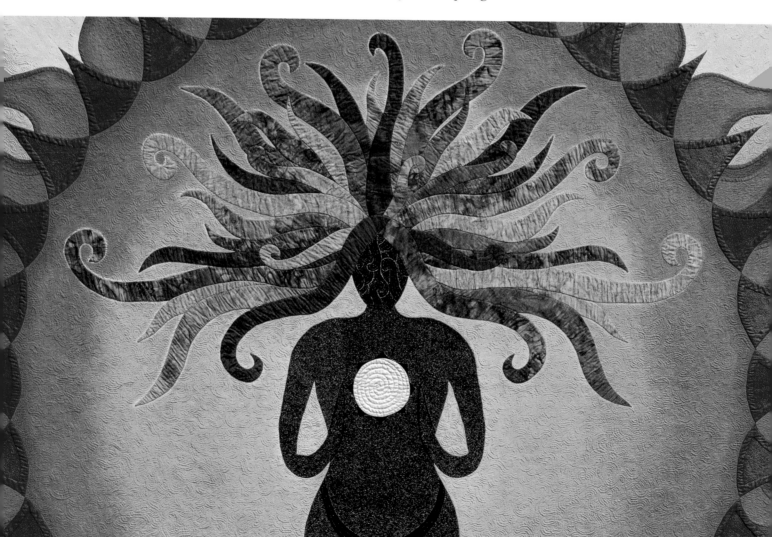

I had used two free motion quilting designs in the quilt so far: Stippling and McTavishing. I'd memorized the steps of these designs so I could quilt them without breaking thread or marking the lines. By this point I was so sick of both textures I was ready to quit.

I knew of two other quilting designs, Pebbling and Paisley, but the texture of circles and tear drops didn't seem to fit the flame shapes. I mentioned this issue to a quilting friend, and she asked, "Why not change the tear drop shapes from Paisley into flames?"

"Is that allowed?" I asked, struggling to believe it could be that easy.

My friend laughed. "Of course! Just take the design and change it to be what you want. Make it whatever you need."

I gave it a try and the resulting Flame Stitch design was perfect!

This was a small thing, a simple solution to a niche quilting problem, but I couldn't stop thinking about it. I wondered if I could create more designs by changing the shapes to create new textures. How many designs could I create? What if I made it a challenge?

An idea slowly took shape in my mind. What if I shared a new free motion quilting design like Flame Stitch every day for a year? That would be 365 free motion quilting designs.

I stopped quilting and grabbed a notebook to jot down the idea. My hands were shaking with excitement once more. *THAT is what I'll do!* I thought. *That will be my blog!*

Of course, just like magic, the name for this quilt followed soon after: Release Your Light. It was a wish, a demand, and a challenge all mixed into one. Only after embracing my creativity and chasing my inspiration had I figured out the next step on my journey.

Once this idea popped into my head, I couldn't think about anything else. I started quilting late into the night, then waking up early to get back on my machine.

This wasn't my usual habit, and it soon began to wear on my body and my family's patience.

But I was ready to finish this quilt *NOW*! I felt like I'd learned what Release Your Light was meant to teach me. I trusted my creativity, and I had an awesome idea for a daily blog I couldn't wait to start.

I was in such a hurry, I considered not painting the quilt as I'd planned.

I hung Release Your Light on the wall and contemplated my options.

She was beautiful, but to be perfectly honest, she looked kinda weird. The black and green appliquéd goddess stood out boldly in the center. I'd quilted the flames with vibrant threads, but over the white background the colors faded to a light pastel. It was definitely not the blazing sunshine I'd originally envisioned.

I soaked the quilt in my bathtub to remove the pen marks and starch from the fabrics. As soon as the water turned pink, I knew I was in trouble.

The dark red backing fabric started bleeding. There was nothing I could do. The fabric around the goddess was soon baby pink. I had no choice. I had to paint it.

I pulled out fabric paints and markers and set to work. I colored in the background around the goddess with yellow colored pencils. I stepped back to check the effect and my heart sank. I'd turned my beautiful goddess quilt into a giant, glowing banana. It looked awful.

It was just beginning to dawn on me what an insane choice this had been. What was I thinking trying to paint this quilt? I was not a painter! I had no idea what I was doing.

But I couldn't quit. I felt like my future was somehow tied to this quilt and I had to finish it. Hours of careful testing, painting and sealing followed.

Again, there was no way to speed up this process, so I used this time to think about my blog idea and how I would share the designs. I'd shot a few videos for skin care and I wondered if I could shoot quilting videos too. I had no idea if there would be an audience for quilting videos, but I was so excited I could barely sit still.

Finally, after a solid month of scrubbing paint into fabric, I finished the black background, sealed the paint so it wouldn't bleed or rub off into other areas, and hung the quilt on my wall.

Release Your Light was my most fantastic finish. She was perfect! I had absolutely no regrets for any of the techniques I'd used. It had taken much longer than I'd expected, but the finished quilt in all her blazing glory was absolutely worth every second she had taken to create.

That dark red backing fabric ended up being more of a blessing than a curse. Not only did painting the quilt surface create an effect that I couldn't have achieved any other way, the back of the quilt turned out just as gorgeous as the front.

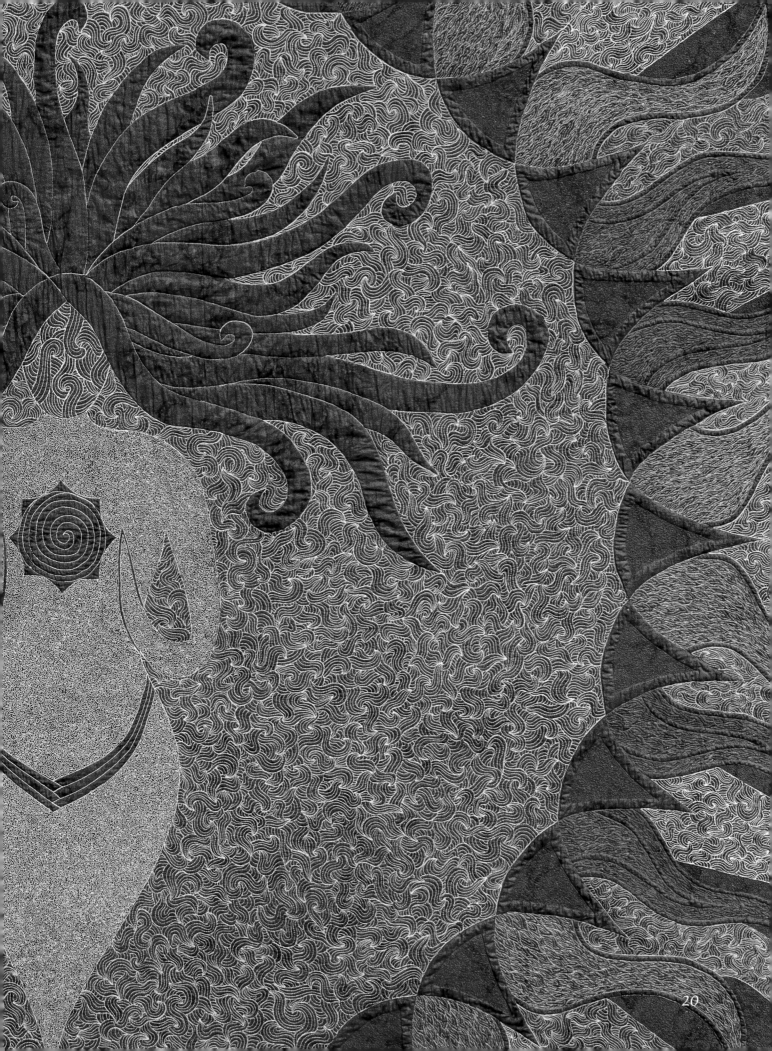

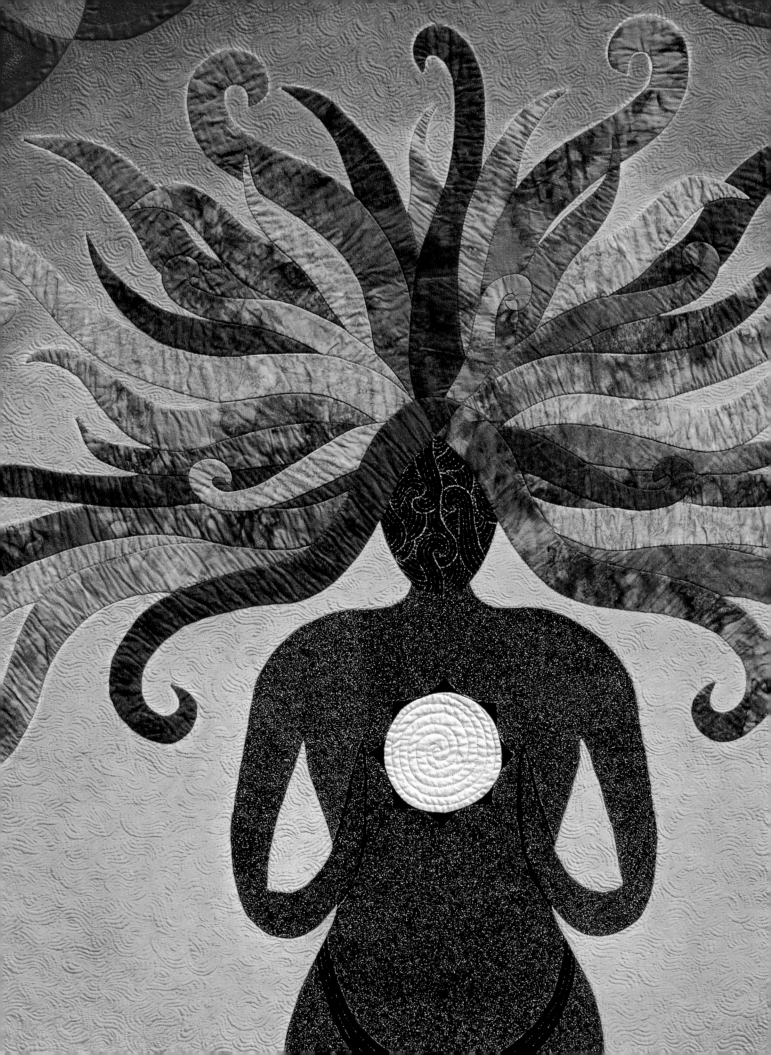

EMBRACING CREATIVITY

I was filled with optimism after finishing Release Your Light, but I didn't launch my blog right away. I kept thinking about it, and to make matters worse, I kept asking for everyone else's opinion.

Unfortunately, Josh didn't support my idea in the beginning. He thought my skin care business was a safer bet. It didn't help that I couldn't explain how I was going to make money with this quilting blog.

What I really needed was someone else's permission to try this crazy idea. I needed someone to tell me to begin and to believe I could do it.

Luckily my father-in-law, Chet, said the magic words. We were talking about something completely unrelated and he suddenly sighed and said, "Just keep quilting, Leah."

His words signed the permission slip I needed. I could begin.

The next day I stitched seven new designs on small practice sandwiches. I took the quilted squares to a guild meeting to show my friends. They loved the idea. One of the quilters asked if she could take a square home with her. She wanted to stitch that design in her next quilt!

The following evening, I started my blog. The original name was *365 Days of Free Motion Quilting Filler Designs.*

I wrote a welcome message and the list of rules, committing myself to the project. Then I put together the first design post with a photo of the front and back of Shadow Waves, the first square I'd quilted. I hit "publish" and clapped my hands in excitement. The blog post was perfect! I was brimming with excitement as I told Josh what I'd done.

His face fell. "I thought you were going to focus on skin care," he said. "I don't think this is a good idea."

Keep in mind it was 2009 and the economy was still in a deep recession. Everything looked bleak and we weren't sure Josh's job would continue to support us.

His opinion was valid. He wasn't trying to hurt me, but his reaction shattered my fragile confidence.

I took a deep breath and stared at the blog post I'd just created, my eyes brimming with tears. For a few minutes, I considered deleting it. I could erase the blog with one click and quit before anyone knew about it.

I stared at the computer screen and slowly put myself back together piece by piece. My confidence had shattered because it had been based on everyone else's opinions and support. I hadn't been able to stand up to a single critical comment.

But that was about to change.

I realized I'd have to begin this creative journey on my own and without my husband's support. I'd need to be my own cheering squad and motivational coach and permission slip signer. I'd have to stop waiting for other people to tell me what to do.

I didn't quit. I didn't delete the blog.

Every day for the next eighty days, I shared a new quilting design. I added videos with the fourteenth design, and that changed everything. Suddenly my inbox was filled with emails about quilting instead of skin care.

Quilters found the blog and loved it. They shared it with their quilting friends and local guilds. They asked questions about the tools and supplies and the sewing machine I was using.

When I sent them links to other websites, many quilters asked if they could order from me instead. They were so grateful for the information I was sharing, they wanted to give back in any way they could. My creative quilting business had officially begun!

I know none of this would have happened without Release Your Light. This quilt gave me permission to embrace my creative passion and to take the next step on this journey.

When I looked at that blazing sunshine, I found the strength to push back against the fear of walking this path alone. Every stitch I took and every inch I painted helped me trust in my inspiration.

Even now when I look at this goddess quilt, I think:

THAT is my light, my creativity. THAT is inside me.
What do I need to do to release my light today?

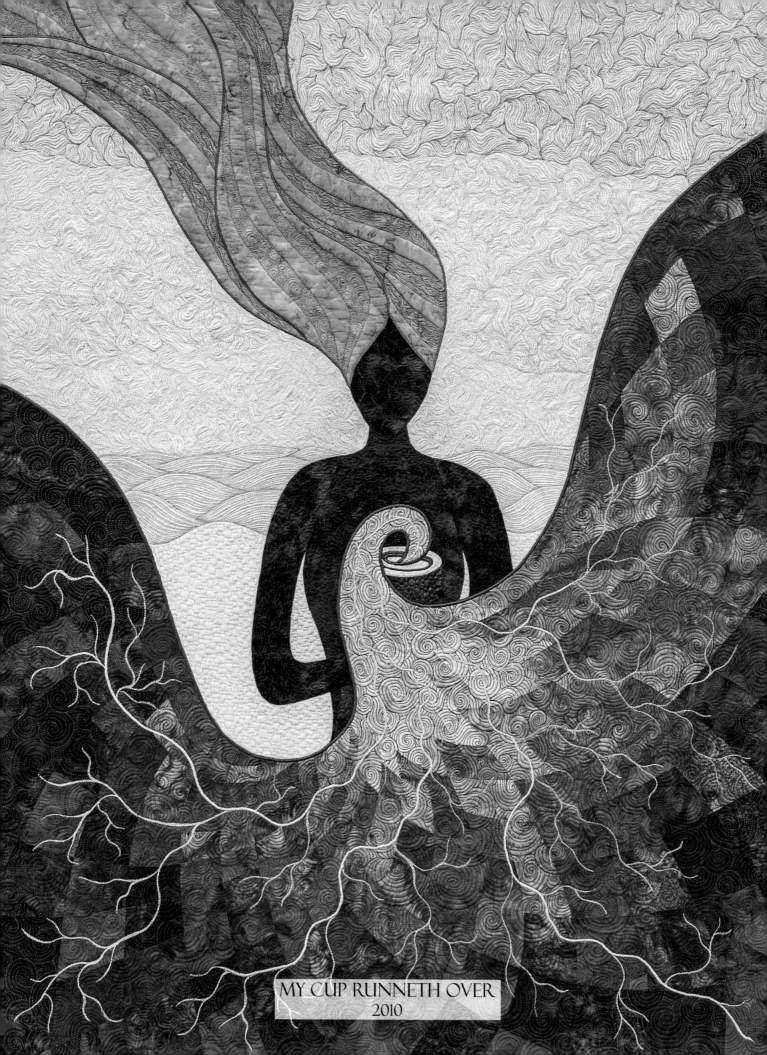

MY CUP RUNNETH OVER
2010

GRATITUDE

The inspiration for this quilt slipped into my heart when I was painting Release Your Light. While washing out my brushes, I could hear Josh and James playing upstairs. I smiled as a wave of gratitude washed over me. I was only twenty-five and already living the life of my dreams.

I cupped my hands together and imagined my gratitude overflowing like water in a fountain.

I love my life, I thought. *I love what I have with Josh and James and I love what we're building together. I am so thankful for all that I have. My cup is running over.*

In that moment I felt blessed beyond belief. All my anxiety about painting Release Your Light melted away. My fear was powerless against the force of my gratitude.

Unfortunately, I couldn't pursue this inspiration immediately. Starting the Free Motion Quilting Project changed my life in ways I never expected. It was an enormous amount of work and it took a long time to learn how to plan designs, shoot videos, and blog daily.

Almost overnight I began receiving requests to travel, write books, and teach classes. I had to consider each request carefully. I wasn't comfortable signing contracts that would commit me to attend events several years in the future. My son was so little, I didn't want to travel away from home.

I decided to stay home and focus my energy on blogging daily and creating books and DVDs to sell on my website. I was under pressure to build the business as fast as possible. Josh was already planning to quit his job so he could work with me. That meant our fledgling quilting business had to be stable enough to support our family in less than a year.

Still the inspiration for My Cup Runneth Over weighed on my mind. It was like an itch I couldn't scratch. I was quilting every day now, but not on the creative projects I most wanted to make.

Finally, I opened up a few weeks in my schedule so I could start this goddess. But from the beginning, I felt like I was on deadline. It was as if all those months I delayed starting My Cup Runneth Over counted against me and now I had to rush to catch up.

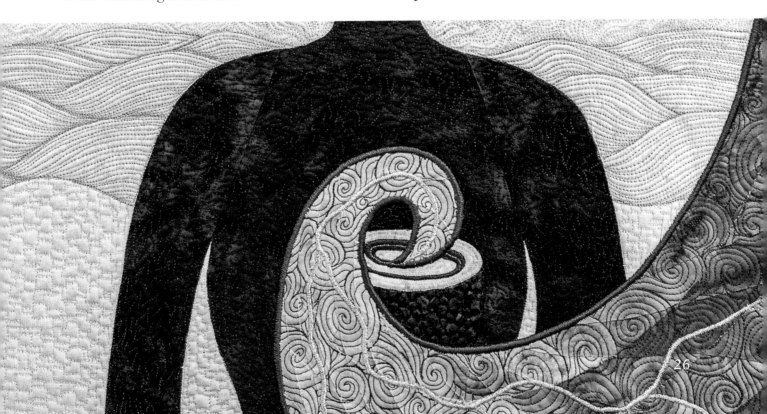

Construction went smoothly at first. Unfortunately, I hadn't taken the time to perfect the lines in the water section. As soon as I began stitching the blue fabrics together, piecing and matching the many seams in this area became a fight.

I had to redraw the lines twice to make the pieces bigger, but no matter how much glue, starch, basting stitches, or cuss words I threw at the fabrics, the seam lines wouldn't match up.

I searched for an alternative method and found raw edge fusible appliqué. I cut out more blue fabric and tried again. It was like putting a puzzle together and all the pieces lined up perfectly. Success!

But my joy at finishing the quilt top was short lived. I hadn't fused the blue fabrics properly and the edges began fraying almost immediately. My Cup Runneth Over was literally coming apart at the seams. I hated it.

It didn't help that my confidence was at an all time low. That month I was also rushing to create a beginner quilting DVD. Halfway through that project, my hard drive had crashed and taken half the videos and most of James' baby pictures with it.

That setback only made me push harder. When the DVDs arrived from the printer, I shipped them out quickly to make up for the delay, only to discover more than half of them were defective. This was a manufacturing error and not my fault, but I still blamed myself.

I was tired and depleted and completely cut off from all the things that had inspired My Cup Runneth Over in the first place: my love for my family and my overwhelming gratitude for all our blessings. Every time I looked at the quilt, I could only see her flaws.

I gave up halfway through the quilting process. I pinned My Cup Runneth Over to a corner of my design wall, turned out the light, and went to bed.

Only when I finally stopped pushing did I realize how far I'd slipped into darkness. I'd made myself completely miserable and for what? A new product for my shop and a pretty goddess quilt?

This wasn't who I wanted to be or how I wanted to feel. I knew I could do better.

EMBRACING GRATITUDE

I put My Cup Runneth Over on hold for four months. It took making another goddess quilt, Shadow Self, before I was able to return to this project with the right intention and attitude.

When I was ready to start over, I sat down and took a long look at My Cup Runneth Over. It wasn't a wasteland of mistakes as I'd previously thought. It wasn't perfect, but she was definitely worthy of being finished.

Fixing this quilt was exactly what I needed at this time. I'd dug up a lot of darkness while making Shadow Self. Working on My Cup Runneth Over helped me focus on all the good things in my life. My childhood hadn't been perfect, but now I had a family of my own to love and cherish.

I opened my heart to gratitude as I ripped stitches from the background. Then I quilted a landscape around the goddess' shoulders to symbolize the life I'd built with Josh and James.

The water area was by far my favorite. Only when I stopped focusing on the negative could I see how perfectly the blue fabrics shaded from light to dark. It was an awesome symbol for the power of gratitude. My cup was running over when I had this inspiration and it was again as I finished quilting the top.

But the blue fused fabrics were still fraying and pulling up on the edges. I pinned the quilt to my design wall and stared at it for a few days to figure out a solution. For once, I wasn't rushing off to fix it as fast as possible. I'd learned the value of slow and steady deliberation.

Then I remembered Dottie Moore, an art quilter who created gorgeous effects with dense satin stitching. She'd taught me Tree Roots, one of my favorite quilting designs. Just thinking about that texture gave me chills. It was the perfect symbol to stitch over the most beautiful part of the quilt.

I stitched the design in silver metallic thread using a wide zigzag stitch. Luckily this hid the worst of the frayed fabrics.

The symbol of tree roots in this area was absolutely perfect. I believe gratitude is the root of all happiness, contentment, and love. Only through thankfulness can we truly appreciate all the blessings of our lives.

When I hung My Cup Runneth Over on the wall for the first time, I immediately cupped my hands together in front of my heart. The skin on my arms tingled as I felt that wave of gratitude once more.

No matter how bad my day is going, this quilt still helps me tap into that well of thankfulness in my heart. This always instantly makes me feel better.

I am so thankful for all that I have.
I love my life.

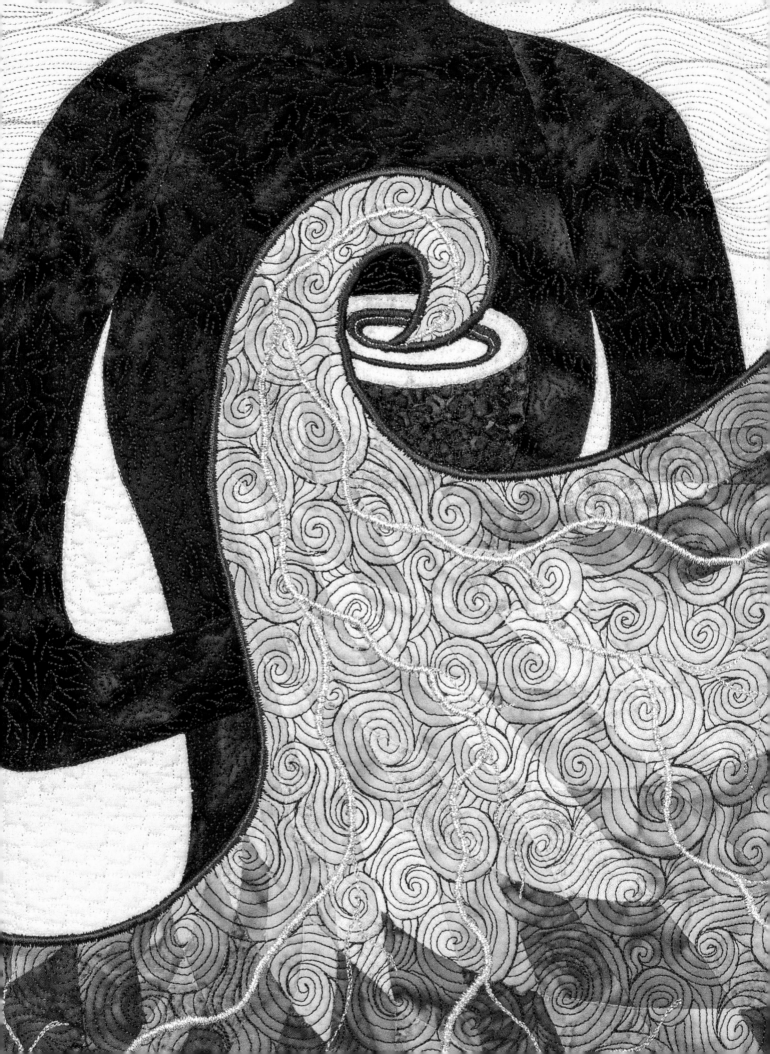

~ PART 2 ~
OVERCOME

Everyone has challenges. I believe how we deal with our issues is our most important, most critical choice.

The next goddess quilts helped me overcome the negativity, grief, past pain, ego, and fear that was holding me back.

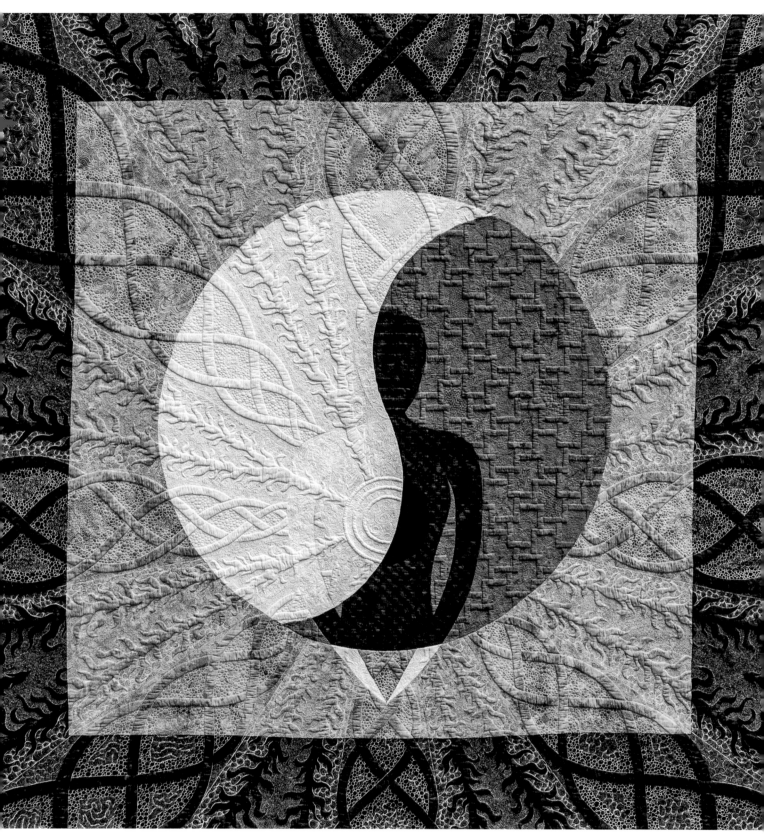

SHADOW SELF
2010

NEGATIVITY

A few weeks after I quit working on My Cup Runneth Over, I began designing a new goddess quilt with a very specific intention: I wanted to overcome the critical voice in my mind.

I'd heard this voice for most of my life. It was a constant drone telling me I was stupid, ugly, weak, and worthless. I'd felt driven to work, to prove myself and my value because that voice had convinced me I didn't deserve my life.

But since James' birth, I'd been carrying the memory of Heaven in my heart. I knew, deep down, it was possible to live without a monster in my head. I just needed to figure out how to turn off those negative thoughts.

I started by questioning the thoughts I'd previously accepted as true. I began noticing when that voice was particularly vicious. The criticism always increased when I was tired or hungry, and especially when I was working on something new and scary.

I struggled to challenge these toxic thoughts consistently. While paging through my sketchbook I decided I needed an image to visualize my mind's positive and negative sides.

As I began drawing, a goddess took shape on the page, set in the middle of a yin yang. This iconic symbol split her figure down the middle, severing her heart and mind with shadow.

It was the perfect image because my critical voice didn't just affect my mind, it also limited my ability to love and be loved as well.

Just looking at this goddess helped me see I had a choice: I could let criticism win and make me feel worthless or I could search for better thoughts to fill my mind.

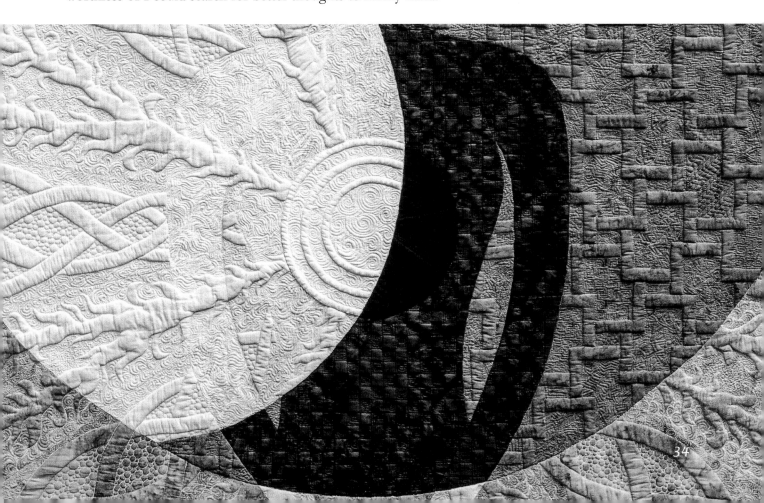

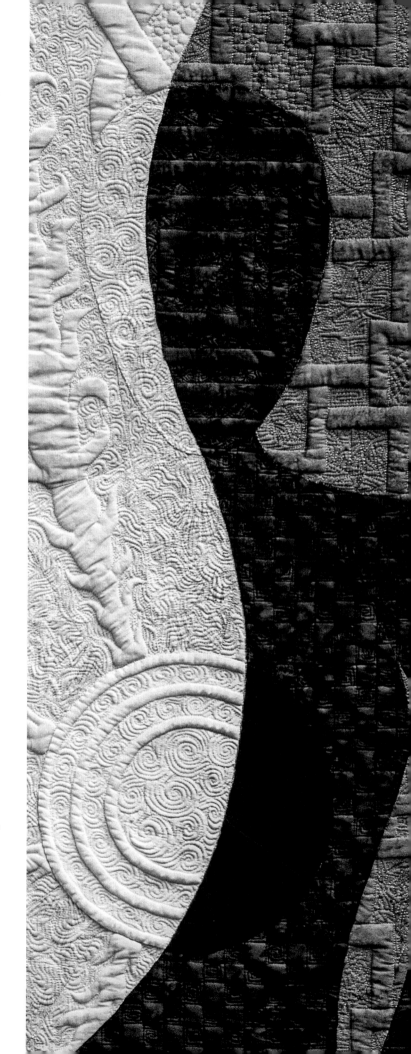

I took my time on this quilt. I'd learned my lesson from My Cup Runneth Over and I was determined to slow down and treat myself with more respect.

I spent several weeks drawing the design and planning the quilting motifs. Only when every aspect of the quilt was perfect did I move to the next step.

I had to take breaks as I constructed the quilt top. It wasn't easy to see the huge black shadow that rested over my heart and mind.

But every time I saw the darkness covering half the goddess, I remembered I was in control of how far that shadow reached.

I wrote about creating Shadow Self and the inspiration behind this quilt on my blog. It was scary to openly share about my critical thoughts. I was worried quilters would question my sanity, or worse, laugh at my vulnerability.

But that never happened. I was surprised to find I wasn't alone. Many quilters struggled with this issue too and their supportive comments had a profound effect on my life.

Around this time I stumbled across an exercise in a self-help book. The steps were simple: make a list of your negative thoughts, then name the person who said that to you.

I suddenly realized the criticism in my head didn't originate with me.

These hurtful words, often said in anger, were never mine. They were cut-downs and insults I'd heard often enough to start repeating back to myself.

One by one, the negative thoughts in my mind lost their power. It was a transformation, one thought at a time.

I worked through this while quilting Shadow Self. I'd never taken such a big issue and tried to "quilt it out" before. It worked! Every day I felt lighter and happier and less critical of myself.

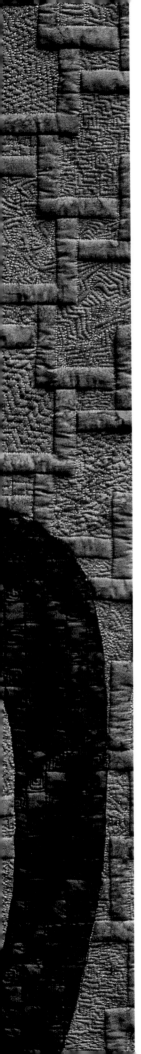

OVERCOMING NEGATIVITY

It took a month to quilt Shadow Self on my home machine. I'd picked many beautiful quilting designs and stitching the small shapes over and over was like a moving meditation.

As I worked, I searched my mind for a positive voice to listen to. I could remember being kind to myself when I was a little girl. Slowly, stitch by stitch, hour by hour, I searched for the voice of my compassion.

One afternoon James banged his head on the kitchen table with a sound that shook the whole house. I was more upset by the goose egg that followed than he was, but he let me rock him in our rocking chair for a few minutes before racing off to play again.

That rocking motion was so comforting, I didn't want to quit. I closed my eyes and wrapped my arms around my body and imagined I was hugging my childhood self.

And as naturally as breathing the words of compassion and love I'd been searching for flowed straight from my heart: *I love you. You're going to be fine. It's okay to let go and relax because I've got you. I'll never leave you and I'll never let you go.*

Day after day, this voice of compassion grew stronger and louder. I probably looked crazy, hugging myself as I rocked back and forth, but I didn't care. It felt good to love myself this way.

As I finished the last stitches on Shadow Self, I couldn't help but compare it to Release Your Light. That quilt had been so slow to quilt and tedious to paint the summer before. Shadow Self had been faster, lighter, and easier. One step had flowed seamlessly into the next, and I'd finished it much quicker than I'd expected.

But the benefit of making that quilt went beyond quilting. I realized I had the power to choose my thoughts. I could dwell on negativity and all the ways I wasn't good enough or I could focus on the positive with acceptance and compassion in my heart.

Before starting Shadow Self, I almost always had music or an audiobook playing while I worked. I'd needed noise to drown out the criticism that constantly nitpicked my work. But by the end of this project, I could work in silence because I'd found peace in my own mind.

After finishing this beautiful quilt, I returned to My Cup Runneth Over. Overcoming my critical thoughts had opened the door for gratitude.

Unfortunately, finishing two special goddess quilts in one month set a precedent I would repeatedly strive for, but never achieve again. I also misinterpreted one lesson from Shadow Self.

I thought I'd worked through my negative voice by quilting out my darkness. I wrongly assumed that if I made an entire quilt devoted to the pain of my past, it would set my heart and mind completely free.

But freedom does not exist in darkness, as I was about to discover, and all paths of self-discovery can lead in two directions.

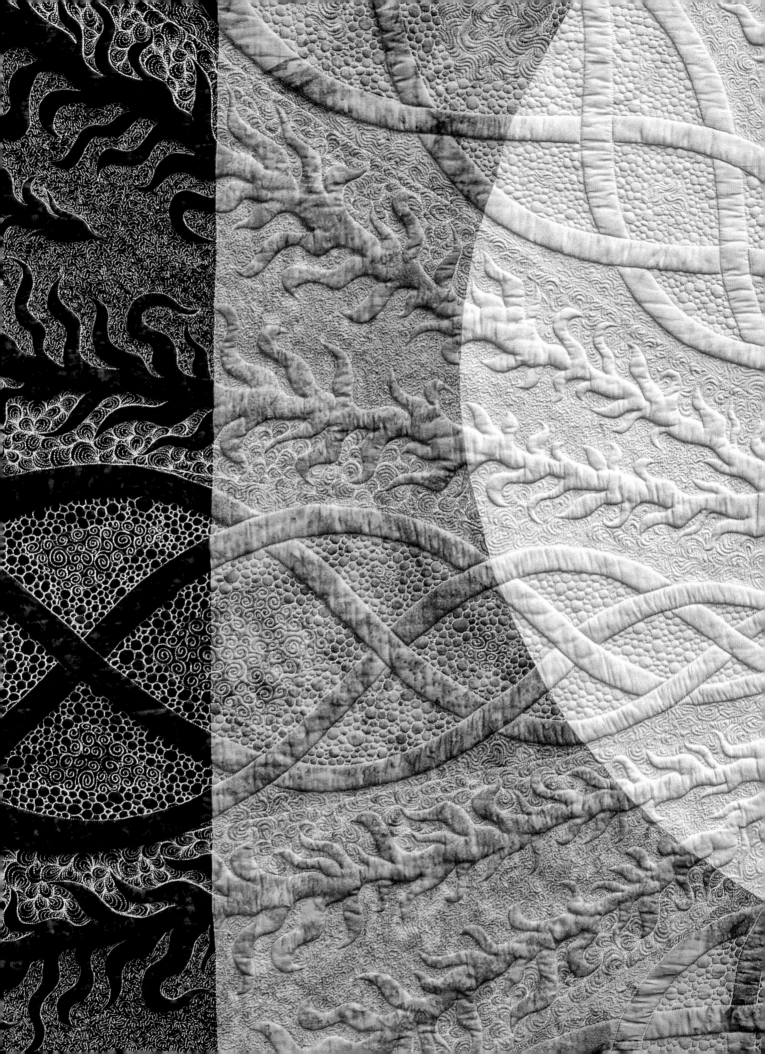

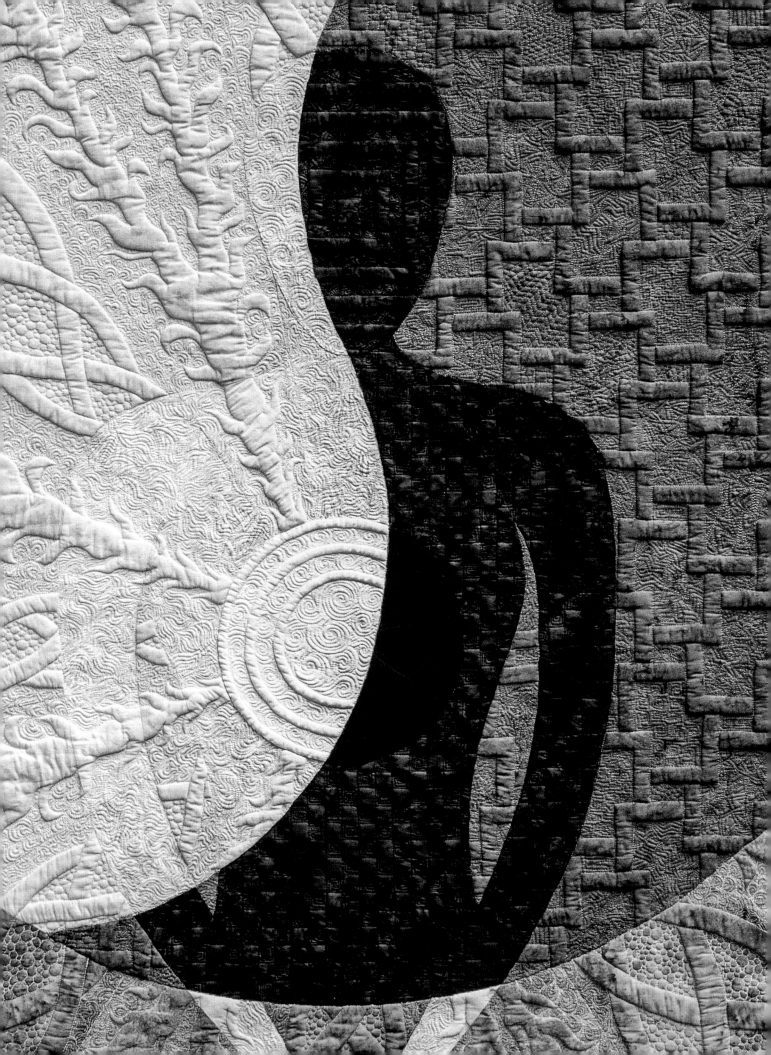

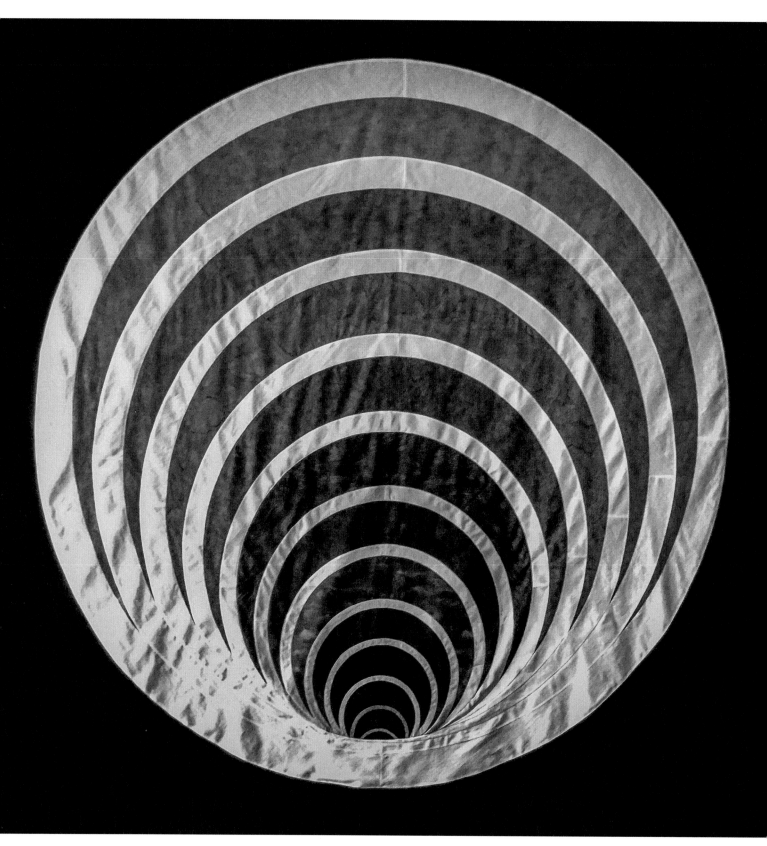

SINKHOLE
2010

PAST PAIN

In 2010, storms opened a massive sinkhole in South America. I found an image of a parking lot that looked perfectly normal. But after a violent storm, a gaping hole had opened in the middle, revealing a cavernous abyss hidden just below the surface.

Something about that sinkhole called to me and I began designing a quilt from this inspiration. Making Shadow Self had been so helpful, I thought making a quilt filled with the darkness and pain of my past would somehow set me free.

My heart was in the right place, but my logic was flawed.

Where there is no light, there can only be darkness. I failed to see that I'd designed a quilt with no hope, no upward movement, and certainly no chance for healing from the process.

As I pieced the interlocking rings of Sinkhole, I ruminated about the past. I remembered playing behind a big pink chair when I was a little girl. It was the only space I had to myself where I didn't have to clean up my toys. Out of sight, I was less likely to be teased by my sisters or criticized by my mother.

Behind that chair I played with toys and I made things. I folded origami boxes and sewed clothes for my dolls. That time I spent crafting built strength and dexterity in my hands.

That's when I made a connection: I was good at quilting only because I liked to keep my hands busy while I hid behind the chair. If I hadn't needed to hide, I wouldn't have this skill.

This realization was devastating. My hands suddenly seemed tainted and twisted. I could never look at my abilities the same way again. This quilt had revealed a truth I'd never wanted to discover.

I wish I'd stopped there, before Sinkhole was complete. I wish I'd taken the lessons and realizations I'd learned and stopped digging. I wish I'd set the past aside and turned back into the light.

But I couldn't stop. The quilt top had come together in a matter of days and now it needed to be quilted.

I decided to fill the dark rings with the most critical, hateful thoughts that had poisoned my mind for years. I thought if I stitched these words on fabric, I'd forever free myself from their influence.

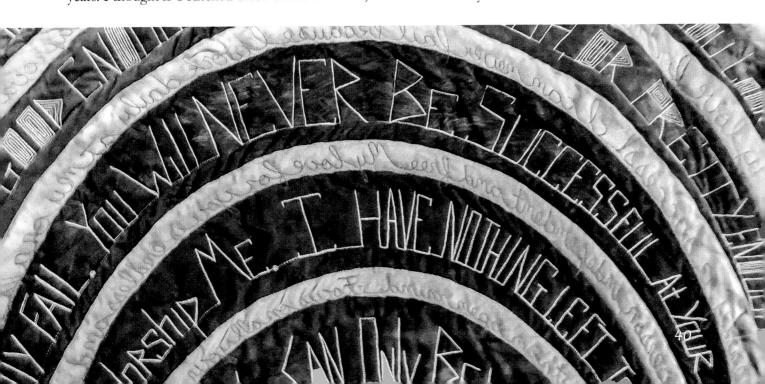

40

Within days I slipped into a depression much darker and deeper than anything I'd experienced before. I sat and quilted and repeated these destructive words over and over in my mind. Unfortunately this gave them more power, not less.

It was during this time that I decided there wasn't enough space in my life for my mother or sisters anymore. Most of the words I was stitching on the quilt were things they had said to me. I was so angry and hurt, I couldn't stand speaking to them.

Like ripping the stitches out of a quilt, I broke the threads of communication one by one. I thought this was a positive change that would solve all my problems. But I only succeeded in isolating myself in a dark hole, exactly like the quilt I was making.

Finally, thankfully, I reached a breaking point. Some emergency warning bell went off in my mind and I realized how sad I'd become. I asked Josh for help and he encouraged me to stop working on it. I folded up Sinkhole and put it away.

Months passed. I created Hot Cast to take my mind off many things. More months passed.

One evening Josh asked if I was ever going to finish Sinkhole. For the first time, I honestly admitted I never wanted to see that quilt again.

"I want to burn it," I said.

We took Sinkhole outside and set it on fire. Watching that quilt burn was the most positive thing to come out of that experience. I felt the darkness lift as the burden of finishing it disappeared.

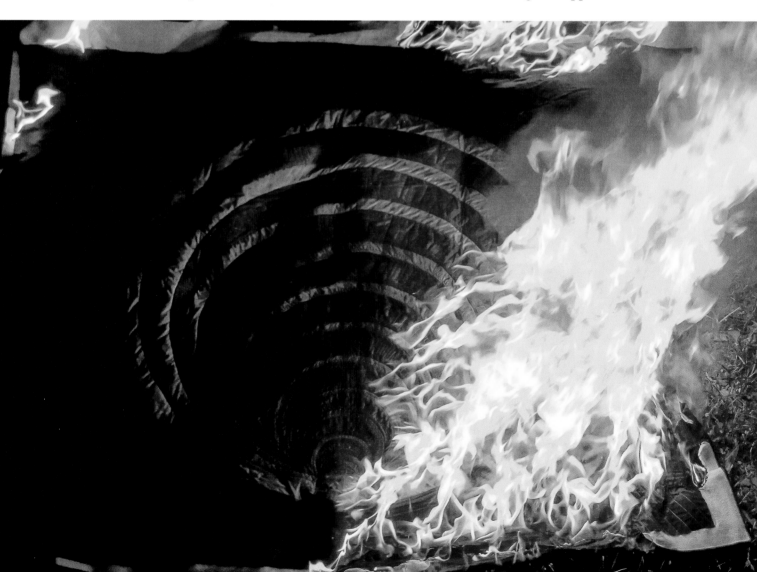

But even then, I couldn't let go of the Sinkhole design. The 3D effect of the rings was so unique, I didn't want to throw the master pattern away. It was such a perfect symbol for my pain and anger and the dark void I'd opened in my heart.

I remembered a sketch I'd created years before of a goddess emerging from a vertical crack with her arms raised to embrace the sun. Originally she was emerging from a traditional wholecloth quilt, but the design hadn't felt right so I'd put it away.

I pulled out that goddess sketch and lined it up with the rings of Sinkhole. The two designs, created years apart, fit together perfectly. This goddess already had a name too: Emergence.

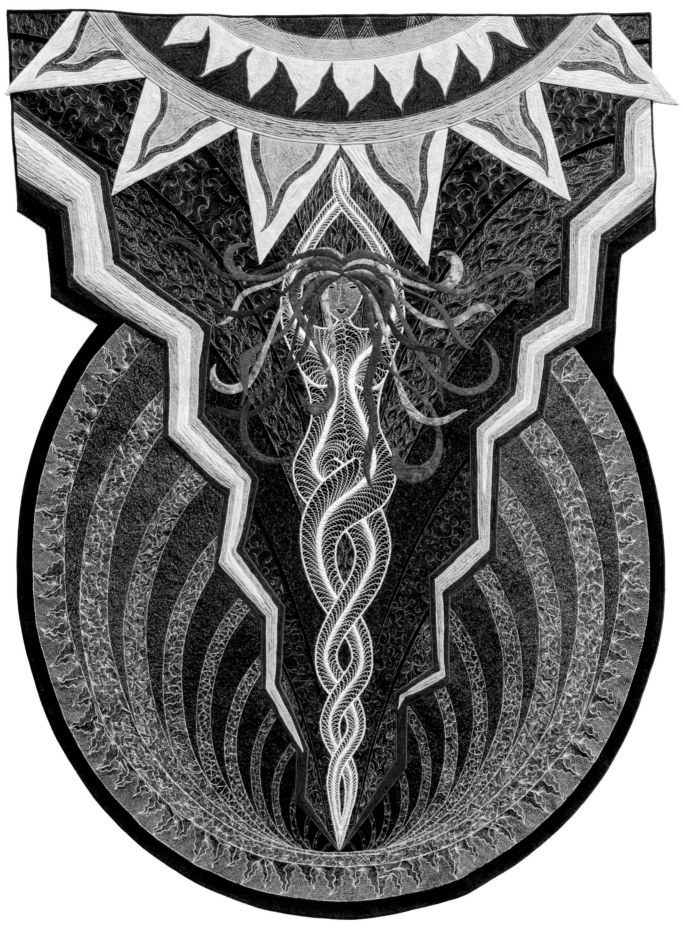

EMERGENCE
2012

OVERCOMING PAST PAIN

Emergence wasn't an easy quilt to create. The dramatic difference between the gray Sinkhole on the bottom and the explosive goddess above created an intentionally unbalanced design. This jarring effect wasn't quite what I was expecting. For a long time, I didn't like this quilt.

Eight months after I finished Emergence, I made a major change to the design. I added hundreds of mini feathers to her body and gave her pink hair so she wouldn't look so bald. I added paint so her figure stood out better against the dark background and I stitched a face with eyes and a mouth, something I'd never done before.

Even after I made these changes, I still felt ambivalent about this goddess. It took several years to understand why. Emergence represented a woman who had been inside the Sinkhole, exactly like me, but she was breaking free and releasing the pain of her past.

Emergence symbolized forgiveness.

But I wasn't ready to forgive. I was so blinded by my anger and pain, I couldn't recognize the symbolism I'd stitched into my own goddess quilt for *years*.

Eventually I learned that past pain couldn't be overcome by digging into it, wallowing in it, reliving it, or even quilting it out on fabric. Past pain must be voluntarily released.

It is a choice: to clench your fist tight around the pain or to willingly release it and embrace the light.

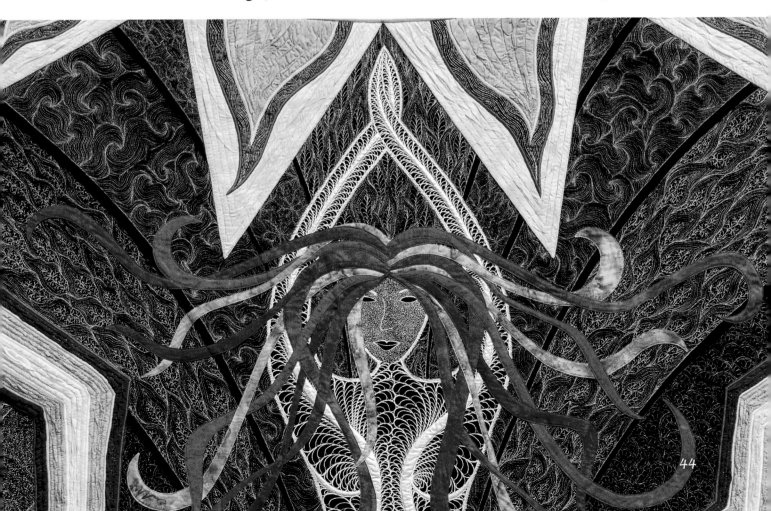

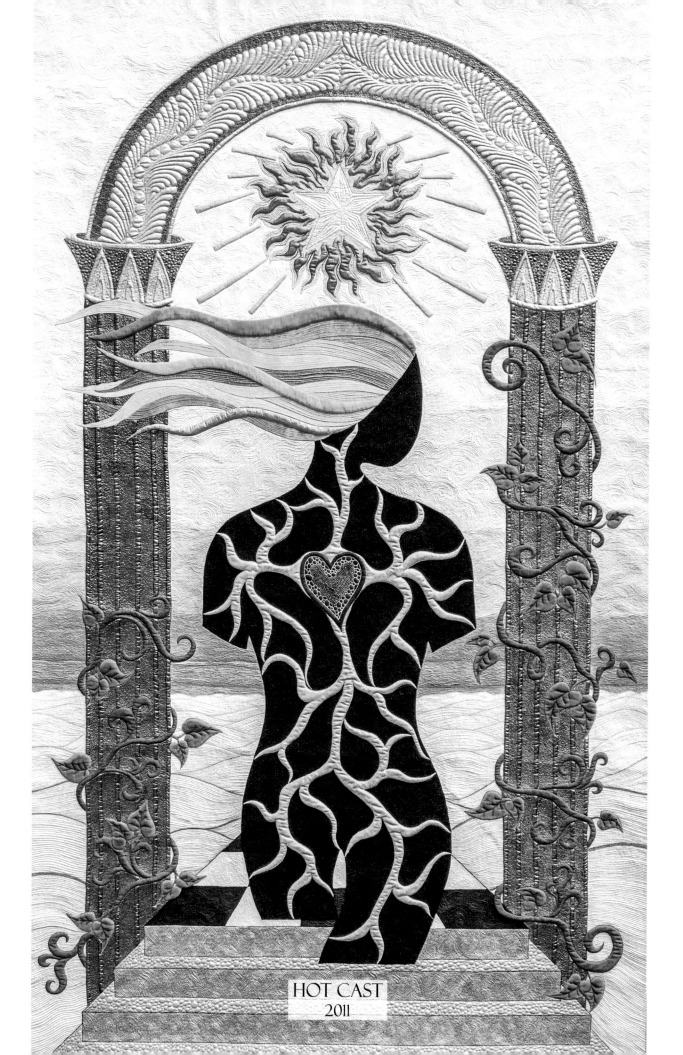

HOT CAST
2011

GRIEF

I began drawing Hot Cast barely a day after folding up Sinkhole. My goal was to create a goddess that would help me heal and move past the revelations I'd discovered in that depressing quilt.

I thought I was drawing a goddess that represented rebirth and learning how to love myself, but that's not what I ended up creating.

A month before, we'd had to put our beloved greyhound to sleep. Josh and I had adopted Jinjo the year we got married and she was very much like a child to us.

We'd shared a tiny apartment with this big dog. Jinjo had slept in a crate at the foot of our bed. She spent most of the day happily napping on the futon and getting up occasionally to take a walk around the neighborhood.

Jinjo was lounging in the corner of the room when James was born. She patiently tolerated him pulling her tail as a toddler and never barked when he crash landed in her dog bed. There was no sweeter animal in the world than our special girl.

I hadn't realized just how much I loved my dog until the day I lost her. I hadn't had a lot of time for Jinjo after becoming a mother and starting my business. When she suddenly got sick, I was annoyed at having to clean up her messes on the floor.

I didn't register what was happening until we were at the vet and the needle was going into her leg. She collapsed into my arms on that silver table and my heart broke into a million pieces.

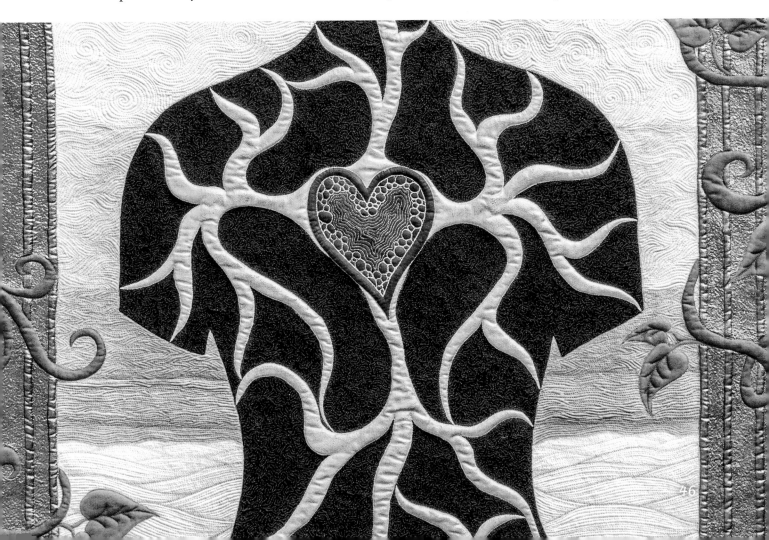

But I didn't allow myself time or space to grieve. *She was just a dog,* I thought. *She wasn't actually my daughter. Why can't I let this go?*

But I couldn't let it go. I kept thinking if only I'd acted differently when she got sick, if only I'd been more loving, if only I'd been less distracted and irritable, she would still be alive.

If only I'd done something, I wouldn't have lost her.

It didn't help that in the last minutes of her life, I'd forgotten to tell Jinjo I loved her. All I had to do was say the words, but in the overwhelming confusion of that moment, I failed to express my love. She slipped away without hearing how much she meant to me.

OVERCOMING GRIEF

Because of the pain I'd unearthed with Sinkhole, I didn't realize I was grieving.

I began Hot Cast thinking I was making a goddess that would help me learn how to love myself. I drew a large heart on her chest and wide veins to carry her molten love. I added signs and symbols from the Freemasons to make this the most complex design I'd ever created.

I picked hand appliqué for this goddess so I could sit and stitch on the couch with my wiggly four year old. I started taking time off and scheduling dates with Josh. I'd learned the hard way not to take the people I loved for granted.

Throughout the process I kept wondering, why does this feel so hard? Where is the "love me" button? Why does loving myself feel like an impossible goal?

The reason was simple: that is not what this quilt was about. I couldn't have designed a quilt about love and acceptance during that time. Diving headfirst into darkness, cutting off my family, and losing Jinjo was too much.

My goddess quilts have a tricky way of being exactly what I need to make, even if I'm unable or unwilling to understand the true meaning of a design. It took me years to look past the metallic paint and pretty symbols to see the woman in the center for what she was: shattered.

All I can say for Hot Cast is this: I am so glad I am not that broken girl anymore.

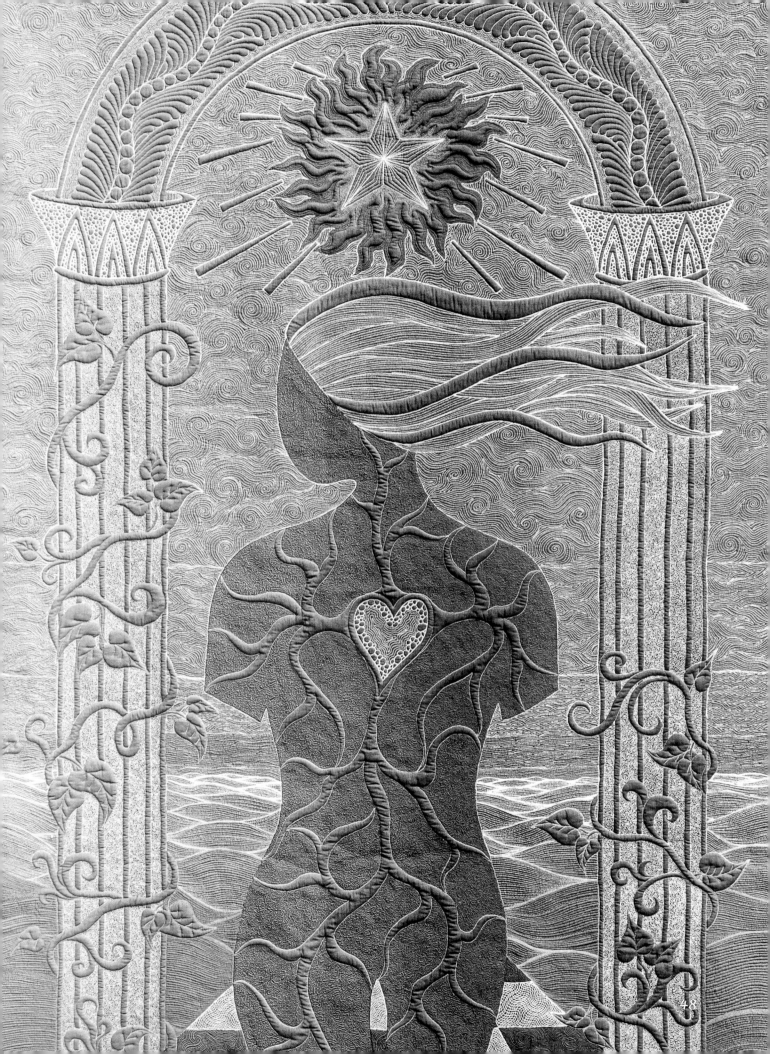

48

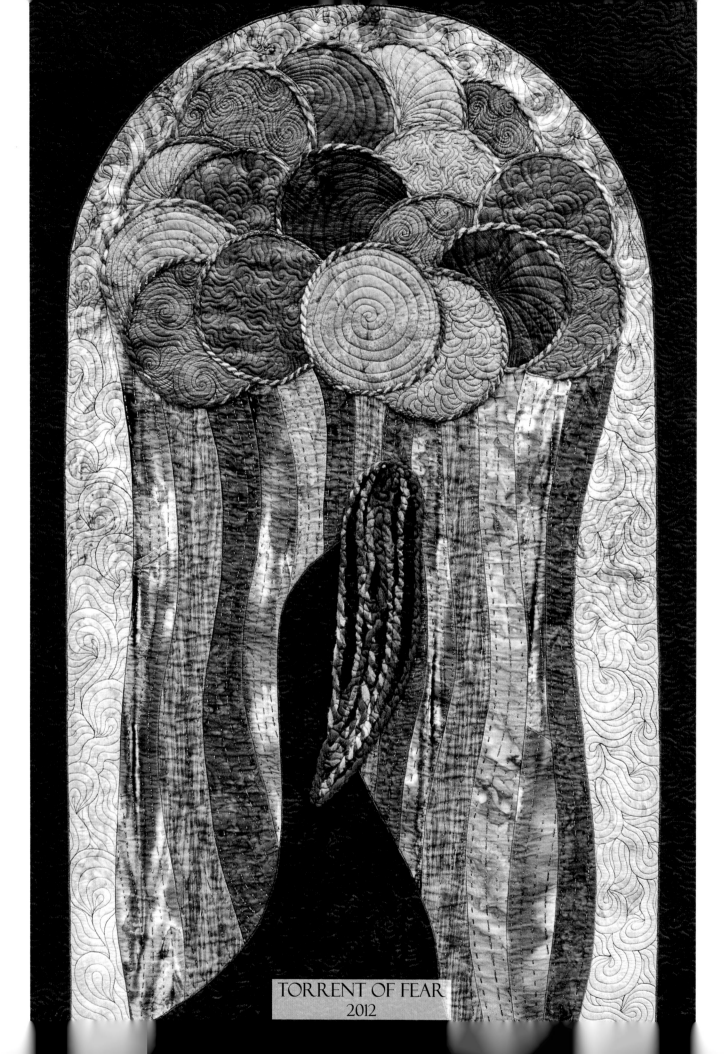

TORRENT OF FEAR
2012

FEAR

I spent most of 2011 stuck in fear. There was a turning point on the horizon and I needed to decide what I would do with my blog once I shared the 365th quilting design.

But I couldn't decide. There were too many options and I was terrified of making the wrong choice. For two years I'd run on autopilot – stitching designs and sharing new videos every week. Changing what was working was risky. This decision could either improve our business or tank it.

An insidious question kept ringing through my head: what will people think? Until this point, I hadn't felt self-conscious about what I shared online, but something about reaching my original design goal made me worry about how I was perceived.

I was so afraid of making the wrong decision, I refused to decide. I ran away from my problems and tried to ignore the turning point looming on the horizon.

This fear soon leaked into other areas of my life. It was like throwing a fire blanket over my creativity. All the light went out.

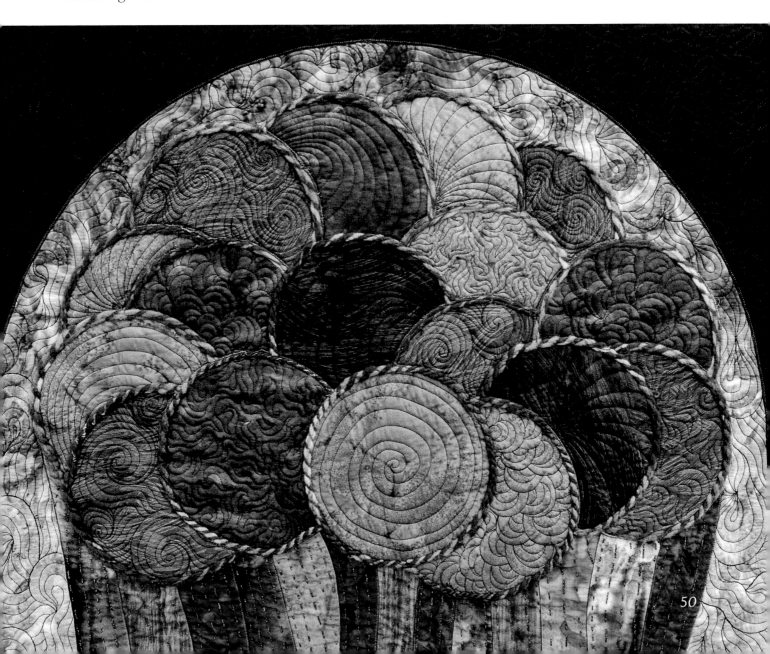

OVERCOMING FEAR

Finally, the deadline arrived. I was forced to decide with no time to prepare, no time to plan. I flew by the seat of my pants and just luckily managed to land on my feet. I decided to start a quilt along with new videos posted every Wednesday.

The second I made this choice, everything got better. It's like the sun came out and suddenly I was free from the fear that had paralyzed me for months.

I decided to make a goddess quilt about fear. While it symbolized a negative emotion, the design and construction of this quilt was the most freeing and fun of all my goddesses.

When I first sketched Torrent of Fear, I wanted to include some positive symbol within the quilt. An umbrella or a covered area that could protect the woman from that deluge of fear.

But after playing with the design, I realized showing fear in all its dark, soul-destroying glory was critical. There was no shelter or protection when I was stuck in fear.

I wanted to see that emotion with no filters and to showcase how fear had effectively snuffed out my creativity. Being unable to make that necessary decision could have cost us everything. I never wanted to let fear get the better of me again.

Making this quilt was like giving myself a present. For years I'd seemed to make choices that only made my life more difficult. It seemed whenever things got too easy, I'd immediately pile on three extra projects with impossible deadlines.

Torrent of Fear was both easy and fast to create because I kept it simple. I knew I was on the right track when I caught myself thinking, *This feels like cheating. Can it really be this easy?*

While making this quilt, I found the answer to that nagging question – what will people think?

I realized two things: people's thoughts were out of my control and also not my business. I can't make money on other people's thoughts! I can't bottle them. I can't sell them, so they are definitely *not* my business.

When I finished Torrent of Fear, I ran my hand over the goddess's hand spun yarn hair. It was hard to tell she was a woman. Fear had dissolved her figure, her beauty, her light and creativity.

As I gazed at this quilt, a question naturally rose from my heart:

Are you stuck in fear?

I ask myself this every time I see this quilt. She is the perfect fear detector.

Whenever I'm getting stuck, I just look at this goddess and ask this question and suddenly, whatever the problem is, it's a lot less scary. I can make the tough decisions and stomach the consequences because I know anything is better than being stuck in fear.

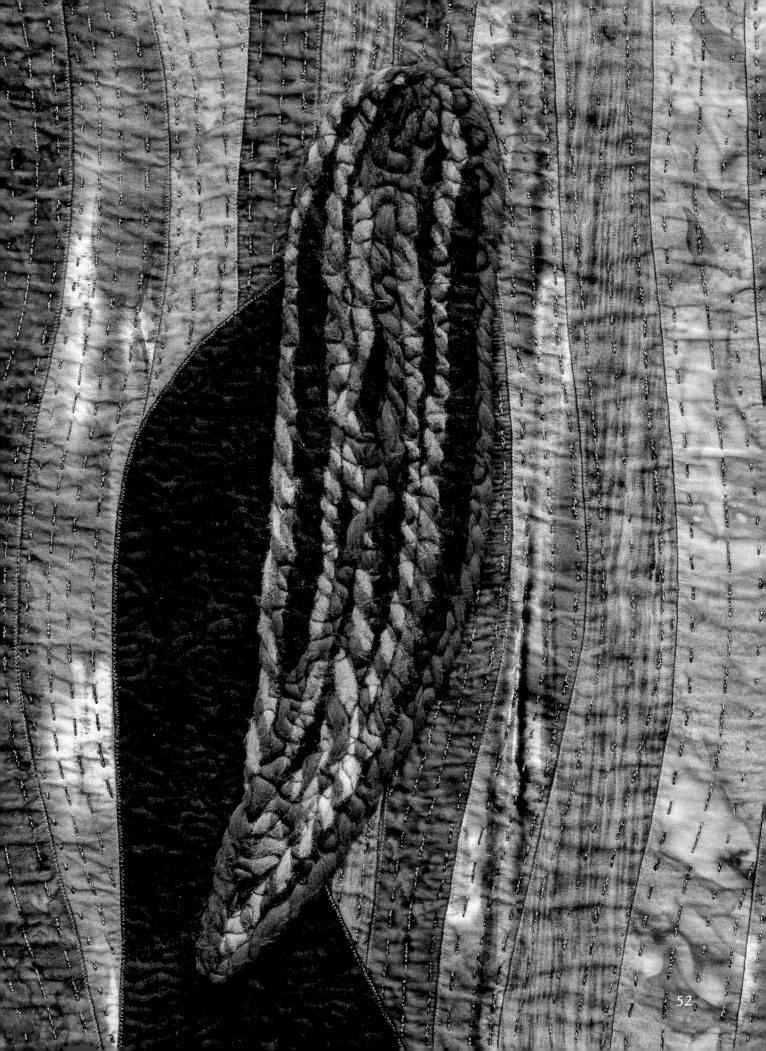

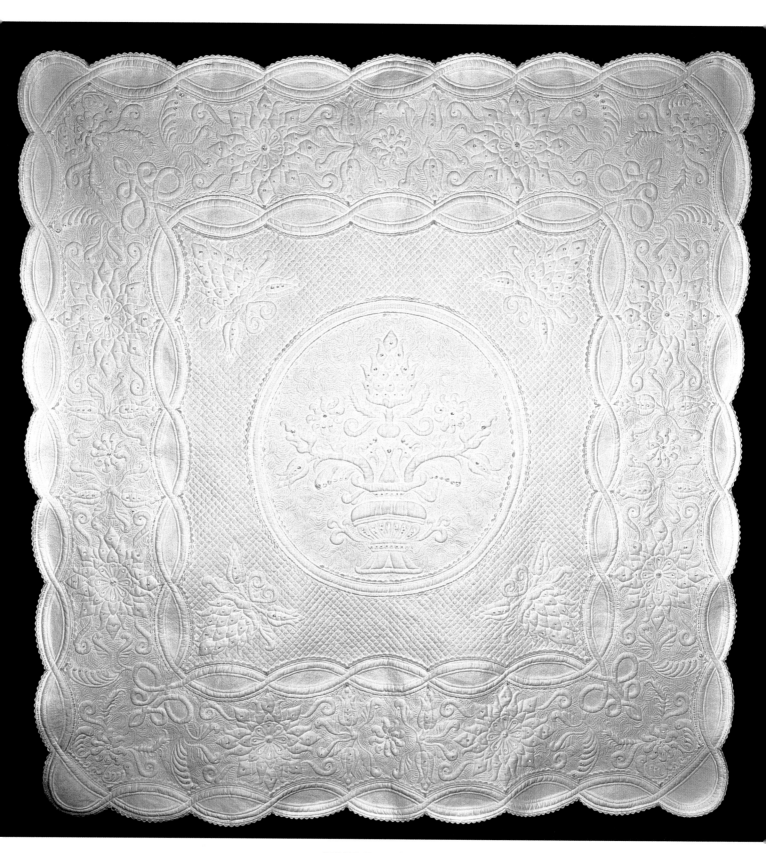

THE DUCHESS
2009

EGO

I didn't set out to make a quilt about ego. Far from it. This was yet another trick this goddess series played on me, and I was duly humbled by the experience.

This story begins with The Duchess, my first wholecloth show quilt. In 2012, it was exactly four years since I'd started this quilt and I was feeling nostalgic. I thought it would be neat to create a new wholecloth like this every four years, like the Olympics.

And just like that sporting event, I wanted these quilts to push me to develop new quilting and design skills. This series would showcase my talent and creativity without getting bogged down with all the emotion and personal drama of my goddess quilts.

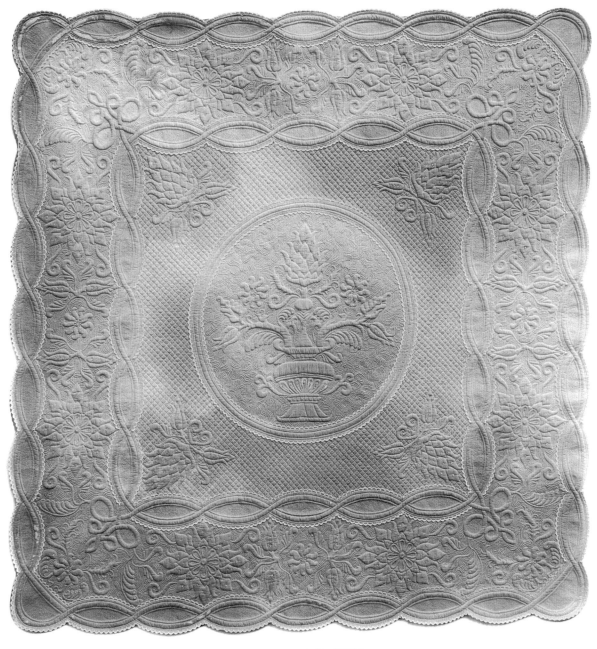

THE DUCHESS
2019

At first, I considered making a copy of The Duchess because this quilt was in such bad shape. Years before, I'd soaked the quilt in a diluted hydrogen peroxide solution. My goal was to freshen up the white fabric that had become discolored after shipping The Duchess to three quilt shows.

Someone at my quilt guild had told me hydrogen peroxide was just like Oxyclean. No, it isn't.

Even very diluted hydrogen peroxide had the power to burn the cotton fabric of this quilt. Three months after I finished The Duchess, it was damaged beyond repair.

But after a lot of sketching, I realized I didn't want to make a carbon copy of The Duchess. While I still loved that quilt, even in its damaged state, I felt no inspiration to make it again. It was pretty and had been challenging to create, but that design held no particular meaning to me.

So I started a new wholecloth quilt, incorporating a few motifs from The Duchess. Instead of a vase filled with flowers, I drew a mythological goddess figure with wings and clawed feet. I kept the vase as a nod to The Duchess and surrounded the center medallion with two fantastic borders filled with my favorite motifs: landscapes, suns, trees, the head of my big orange cat, Shy Guy, and hundreds of feathers.

Yet even though I'd incorporated all my favorite motifs into the quilt, I remember feeling frustrated by the design. It was like an alphabet soup of letters, but no words. The quilt design was pretty, but it held no particular meaning to me, just like The Duchess.

I didn't see the inherent flaw in this wholecloth series. The downside of removing all emotion and meaning from a quilt was the removal of purpose as well.

At first it didn't matter that Duchess Reigns lacked both meaning and purpose. It was an amazingly creative, boundary pushing project. I loved quilting the motifs and clipping away the batting for trapunto. Dyeing the half finished wholecloth dark red was challenging and exciting.

It's when I started filler quilting that the missing piece of this project became obvious. In all other quilts of this style, I'd had a secret motivation to nurture in my heart. Even when I created The Duchess, my dream had been to win my first ribbon at a quilt show.

That desire had kept me focused through the hardest, most boring parts of the project. It was kind of like having a co-pilot sitting next to me. That positive goal had helped me stay focused on the journey through to the very end.

Duchess Reigns didn't have this. I was planning to show this quilt, but I wasn't as invested in the outcome. After winning my first blue ribbon, I didn't care much about winning more.

My brain wasn't munching on a personal obstacle either. I could have focused on a positive emotion like creativity or gratitude, but I didn't. I just sat and quilted for hours on end with no driving force behind my hands.

My co-pilot seat was empty in the beginning, but it didn't remain so for long. Ego and its evil twin sister, perfectionism, soon buckled up for the ride.

For years I'd wanted to lighten up on my quilting style. Quilting super densely was extremely time consuming and tedious. I'd often spend an hour stitching one small section and find I'd barely covered four inches of space.

To make matters worse, I had a habit of throwing more thread at my mistakes. When I stitched badly over a line, I'd quilt back along it to make the mistake seem intentional. But then I had to double stitch everything so all the lines matched.

The dark red fabric illuminated every mistake. Quilting on my home machine put my eyes less than ten inches from the quilt at any given time. I could see every wobble, every skipped stitch, every flubbed line. It drove me crazy when the quilting wasn't perfect.

Soon I was stitching back and forth over every line of every motif. Ostensibly my goal was to make the designs stand out better, but really I was just trying hide every possible mistake.

Perfectionism guided every decision.

When my stitches wobbled around the goddess's feathered wings, I began thread painting the space in between. If I'd thought Microstippling was time consuming, it didn't hold a candle to scribbling on the quilt until the red fabric turned white with layers and layers of thread.

Behind the drive for perfection was ego and the gleeful desire to show off. *Look what I can do! Aren't I talented and special? Who else can quilt like this?*

I knew something was wrong with this quilt about a month after I dyed it. Whenever I'd stopped quilting, I didn't feel relaxed or happy with my progress.

I felt frustrated and angry. Even with all the thread painting, my quilting wasn't measuring up to my high standards. The snail slow pace meant I'd be quilting Duchess Reigns for months longer than I'd expected. The pressure to quilt faster made me irritable because the quilting style I'd established was impossible to speed up.

The time I had for quilting this project had also shrunk. It was 2013 and I'd started a new quilt along, which meant I needed to shoot dozens of videos to get things rolling.

But I wanted to work on Duchess Reigns more. I refused to commit to the quilt I was teaching and often shared videos on this wholecloth instead. The result was a disjointed, confusing mess.

I wasn't being a good teacher. At some point, my ego had convinced me that I didn't need to make a project that flowed logically, made sense, built on established techniques and designs, or resulted in a finished, pretty quilt. I thought everyone could "go with the flow" with me, but instead I nearly flushed my business and brand down the drain.

This crazy train continued for more than six months.

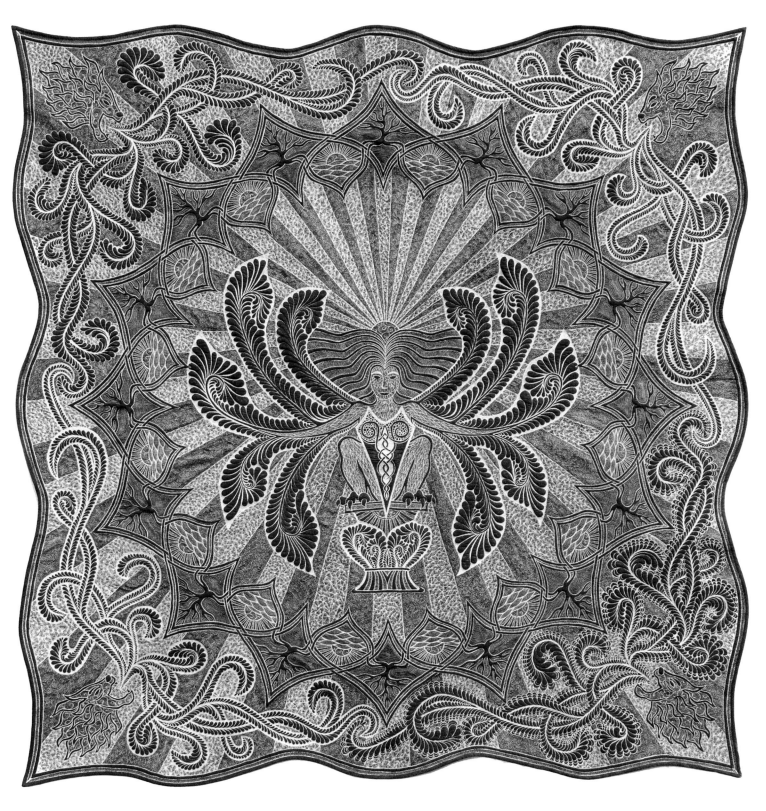

DUCHESS REIGNS
2015

OVERCOMING EGO

Everything changed the day I stretched Duchess Reigns out to check my progress. I instantly noticed something was wrong. The quilt wouldn't lay flat. The quilted fabric rippled through the center and no amount of pressing or stretching helped. My dense, overcompensating quilting had distorted the quilt.

How could I have made this mistake? I wondered. *How could I have messed this up so badly?*

Slowly I put the pieces together. Ego had convinced me that I knew everything there was to know about quilting. I thought I had it all figured out. Even the name of the quilt was egotistical! What did I think I was reigning over anyway?

Ego persuaded me not to bother densely quilting the two smaller projects I'd designed to test my fabric dyeing method. If I had, I would've known dyeing a half finished quilt was a recipe for fabric distortion and pleats.

Perfectionism distracted me by constantly criticizing my stitches. My desire to make the quilt perfect had driven me to stitch too densely. By my own hand, I'd ruined this quilt.

I realized then that Duchess Reigns wasn't just a wholecloth, she was a goddess quilt through and through and had a specific lesson to teach me: you don't know as much as you think you do.

I was thoroughly humbled. I'd thought I had it all figured out, but suddenly I felt like a beginner again, fumbling over basic techniques.

I had to put Duchess Reigns away. It took time to accept the fact that she would never hang straight. She would never be perfect.

I returned to this quilt knowing I had to sit and stitch for hours on end on a project that wouldn't deserve ribbons at a quilt show. And I had to sit and stitch knowing I was the cause.

I had to sit with my imperfection and accept that Duchess Reigns would be a showcase of my flaws and all that I had left to learn. I had to open my heart to humility and grace and own my ego.

This was the lesson packed in a quilt that wasn't meant to have a lesson at all. She was just supposed to be a pretty show quilt, right?

Never again would I begin a quilt with such an empty goal.

I believe making pretty things does make the world a better place. But meaning is necessary. Spending this much time on a project requires having the right intention - not to show off, not to elevate myself above others, but as a vehicle for change and personal growth.

It was a slow, painful process, but I never once considered throwing Duchess Reigns away or burning her like Sinkhole. I had baked that humble pie and now I had to eat it all.

When I finally finished Duchess Reigns, I hung the quilt on the wall and stepped back. Even after blocking with hundreds of pins and steaming her twice, the distortion never disappeared.

It was a lasting lesson: You have a lot to learn, girl. You don't have it all figured out and you never will.

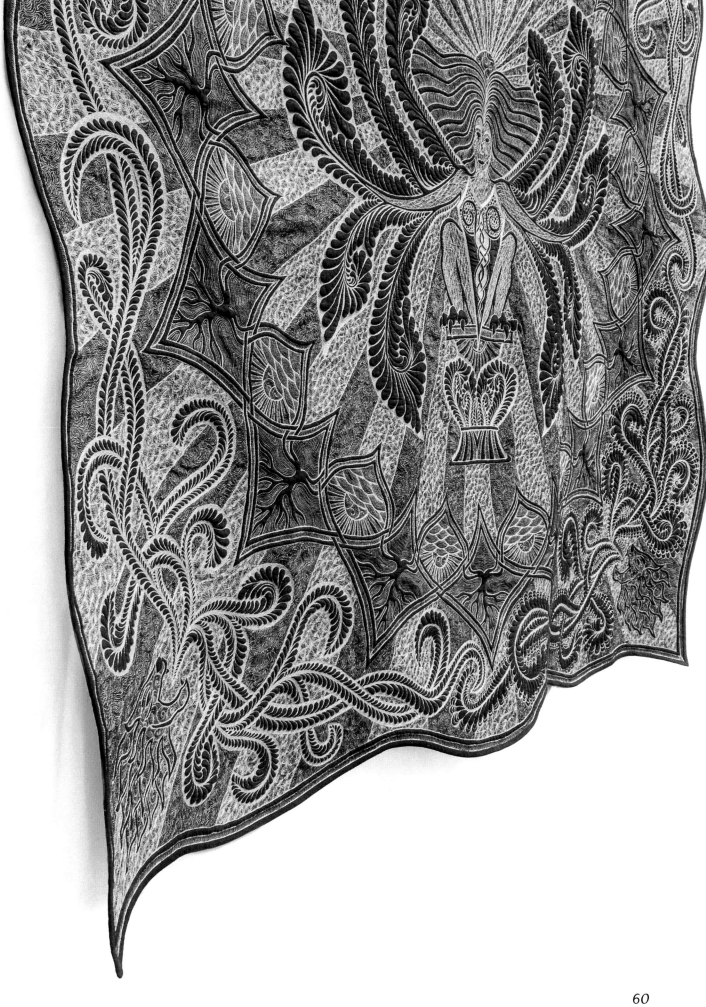

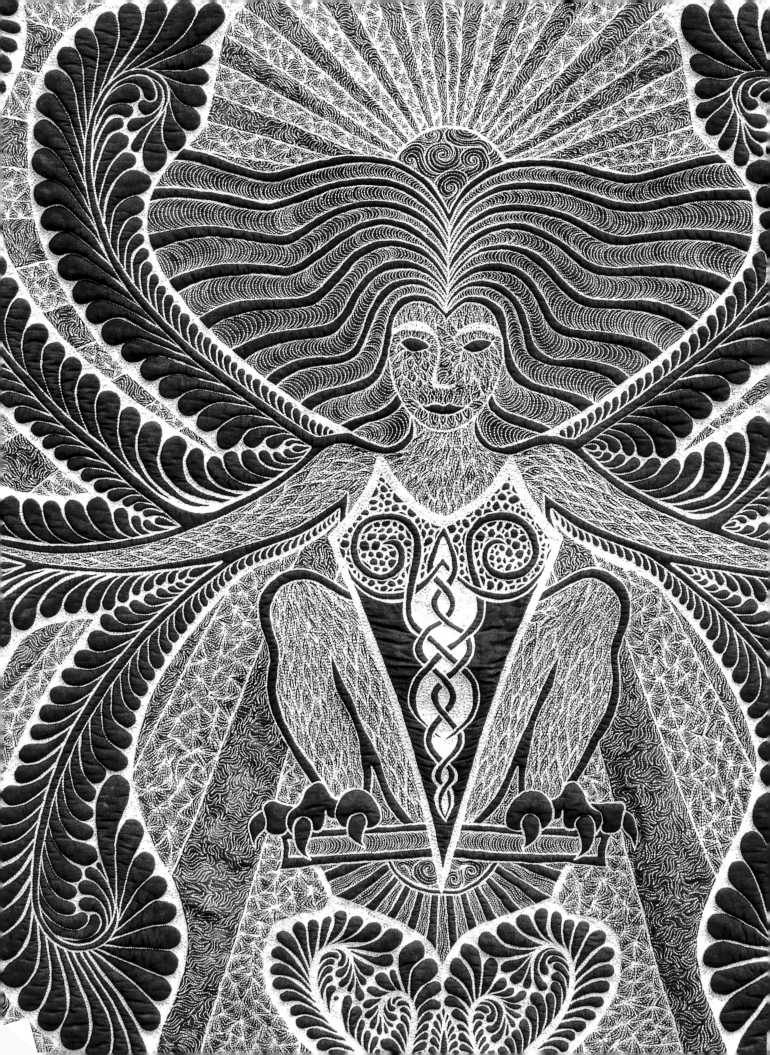

~ PART 3 ~

CHOOSE

As I said from the beginning, I believe
the greatest challenge in life is
choosing to feel satisfied and content
with what we have.

The quilts in this last section helped
me choose forgiveness for myself and
others, courage to change, and
acceptance of all my imperfection.

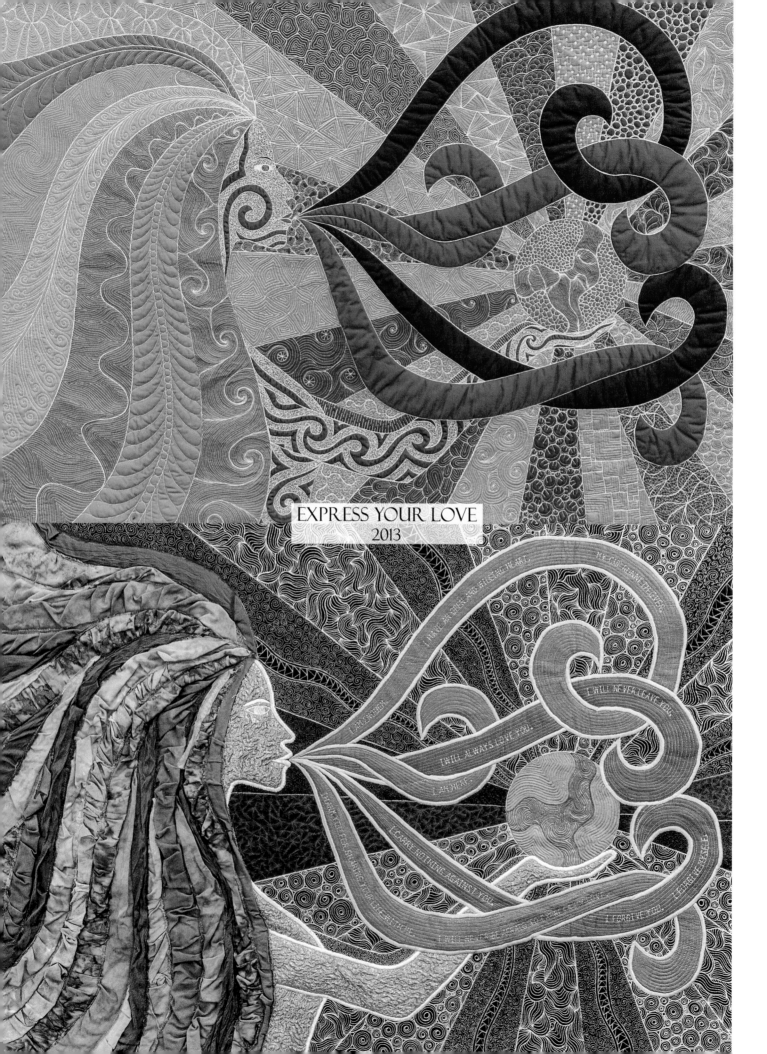

EXPRESS YOUR LOVE
2013

FORGIVENESS

I originally designed Express Your Love for the 2013 Free Motion Quilt Along. My goal was to encourage quilters to make their own goddess quilts and to share new creative techniques.

I kept this goddess very simple so quilters of all skill levels could confidently appliqué and quilt the design. The open space in the woman's hair was perfect for quilting motifs and I loved stitching words into the wide swirls of her breath.

The simple symbolism of this goddess reflected my personal goals as well. I wanted to be more kind and loving to Josh and James. I knew whatever I expressed to my family had an impact far beyond our home.

But I lacked the confidence to commit to this project. I knew I should plan the steps and write a pattern, but I was afraid no one would buy it.

That fearful question, *what will people think?* crept in yet again.

At this point, all of the quilt alongs and videos I'd shared were free. I was afraid if I charged for a quilt pattern, all of my followers would disappear.

This lack of respect for myself, my business, and this goddess design doomed the quilt along before it even started.

It's a good thing I loved this goddess because I ended up making five of her. The first videos I shared were on a black wholecloth version I'd planned to paint after quilting.

But after several bad thread color choices, I set it aside to start another version of Express Your Love using a fabric panel I'd printed with Spoonflower.com. When that quilt hit a snag, I filmed several videos on Duchess Reigns instead.

It was thrilling, in the beginning, to teach techniques like wild appliqué, trappliqué, English paper piecing, and fabric painting. I'd wanted to explore these creative skills for a long time and it felt great to experiment with the wilder side of quilting.

But I didn't share these techniques like a good teacher, breaking things down into easy, understandable steps. I shot the videos like a whimsical artist, running with whatever idea popped into my head, sometimes starting two new versions of the quilt at once before jumping back to the original.

My advice to quilters was, "Go with the flow! Just use this design or technique however you like. Be creative! Have fun!"

But it wasn't fun. It was exhausting. Six months after starting the quilt along, I had four versions of Express Your Love in progress. I was flying by the seat of my pants with no plan for how I would finish any of these quilts. Because I was sharing videos so erratically, quilters became confused and upset, exactly what I'd been afraid of from the beginning.

Behind the scenes, I was stuck. I wasn't making anyone happy and we were bleeding money. I'd committed myself to sharing a year-long quilt along, but it clearly wasn't working. I lost all confidence in teaching goddess quilts.

I wanted to quit. I wanted to get focused and take my business more seriously. But I felt chained to the many versions of Express Your Love I'd created. Didn't I have to finish them all? Didn't I need to explain how to satin stitch that wild appliqué and finish piecing four hundred tiny hexagons?

To make matters worse, I was piling on the pressure to complete an impossible list of goals before my 30th birthday. I wanted to write books, launch workshops, renovate my house, and more. Every day I'd write down the number of days until my birthday, and the list of all the things I wanted to get done. I'd become my own worst enemy.

Finally, thankfully, everything fell apart. I couldn't keep piling on the pressure. I knew I had to stop the quilt along and change what I was doing.

I did something I should have long before: I found a good therapist.

I'd resisted getting help for years because of a bad experience in college. After two visits with the school guidance office, I was given a note to visit the medical clinic upstairs to get on anti-depressants. I didn't want to take drugs. I'd wanted someone to listen and that therapist had failed me.

This time was different. My therapist, who I'll call Jane, listened patiently as I explained the quilt along and showed her my crazy journal.

She cocked her head to the side and asked, "Do you like what you do?"

"I love it!" I practically shouted. "I love what I do. This is what I always wanted to do with my life. Of course I love it!"

"But do you love what you're doing right now?" she asked.

"No. I can't stand it. It's not working."

Admitting this was the first step. I had to be honest and open to the truth before anything could change.

Jane became a referee for my life and business. She helped me focus and use my energy wisely. She'd quickly point out anytime I was living to work instead of working to live.

She'd blow a whistle when I was getting off track and helped me see the most important step to take each month.

During one of our first sessions, Jane gave me permission to quit the Express Your Love quilt along. She logically pointed out that it was a free project that had run its course.

Now it was time to build something new that would correct the mistakes I'd made with Express Your Love. I designed a simple, traditional quilt, broke it down into small steps, and wrote a detailed pattern for quilters to follow.

It took months of effort, working very long hours to plan the project in such detail. Every day I battled the fear that my time would be wasted and that I'd anger my followers for charging for the pattern. But as I crafted the Building Blocks Quilt Pattern, I built confidence in myself and my abilities.

I was a stickler for detail. I discovered that of course I knew how to write a pattern! I just hadn't pushed myself to learn and develop this new skill.

When it was time to launch, I didn't expect much. I was hopeful the project would be a success, but having never shared something like this before, I had no idea what to expect.

Building Blocks became our most successful, most popular quilt pattern. It changed everything for our business, right down to the ownership when we incorporated that year. Josh even quilted his own set of blocks on video to show what it was like for a true beginner.

A few quilters didn't like paying for the pattern, but their emails didn't bother me as much as I'd expected. In the process of building confidence in my ability, I'd also built respect for myself and my worth.

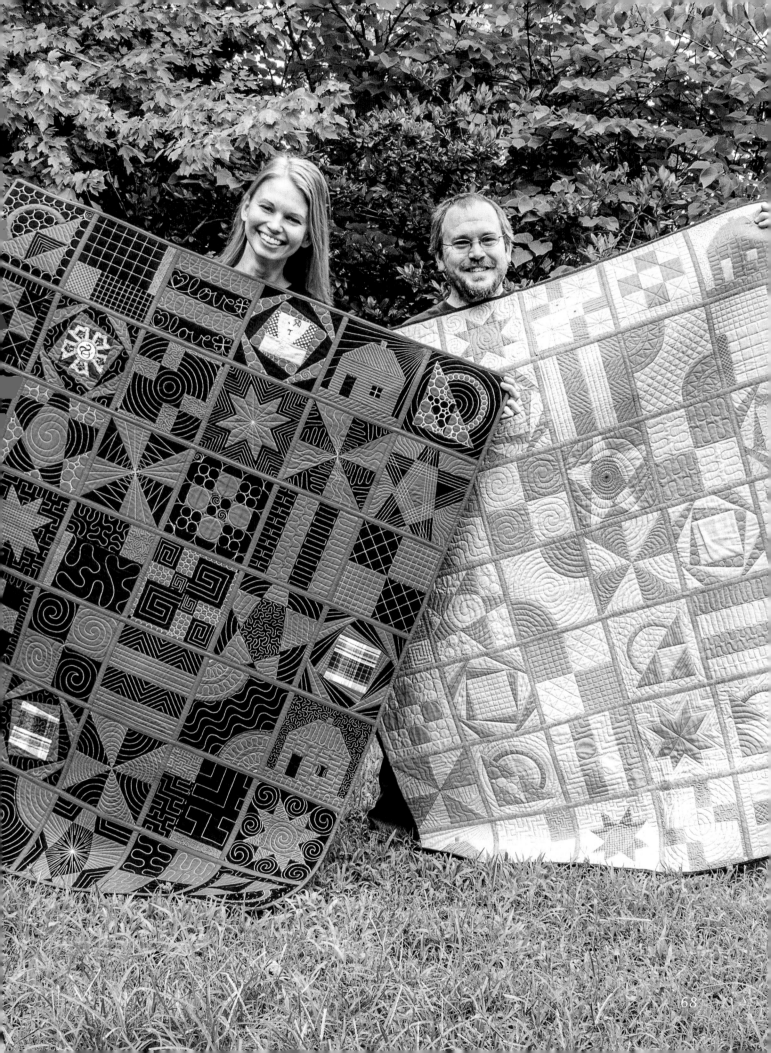

CHOOSING FORGIVENESS

This big win with a traditional quilt pattern had an unfortunate side effect. I became convinced that my goddess quilts could never be as successful. I followed up Building Blocks with a succession of traditionally pieced or appliquéd quilts featuring butterflies, star blocks, and flowers.

Anytime I considered writing a goddess quilt pattern, I'd remember the chaotic mess of Express Your Love and quickly change my mind. I never wanted to do anything like THAT again.

It would take a long time for me to look back on this experience and understand all the ways this logic was flawed. Express Your Love had been a mess because I'd refused to commit to it.

I hadn't had the confidence to even try writing that pattern. I'd disrespected myself and my followers by sharing it anyway, with no logical plan to follow.

I kept all the Express Your Love quilts folded in a drawer, including the mini beaded version I'd started on a whim. I thought it would take years to finish all these quilts. It certainly would have, if they'd stayed in that drawer!

A few years ago I cleaned out my quilting studio and threw away dozens of unfinished quilts I had no desire to complete. The projects I kept went into a special cabinet and I promised myself I'd finish them all, including the many unfinished Express Your Love quilts that had been waiting since 2013.

One by one, I pulled out these goddess quilts and finished them. Just stitching for fifteen minutes a day helped me make progress on each project.

While a lot of work remained, it wasn't the massive amount I'd inflated in my mind. I realized these quilts had been stuck because I'd been stuck in guilt and regret over making them in such a haphazard way.

The hardest thing to accept was that I'd been doing the best I could at that time. Hindsight has never been easy on me. I always judged my actions negatively. I should have done better. I *could have* done better.

But that wasn't true. I didn't have the right skills or knowledge. I didn't have the confidence or respect required for the job. The quilts and videos I'd shared were the very best I could create. Stitch by stitch, I came to terms with this and stopped berating myself for all the ways I thought I'd failed.

A funny thing happened when I forgave myself. I found space in my heart to forgive others. After years of missing them, I reached out to my sisters.

We rebuilt our relationships carefully. I discovered now that we were all mothers, we'd grown up a lot from who we were as kids. Once I was able to set the pain and anger of my past aside, there was so much more space for new memories and fun times together.

Our holiday gatherings increased exponentially in size and volume and were filled to the brim with light and laughter.

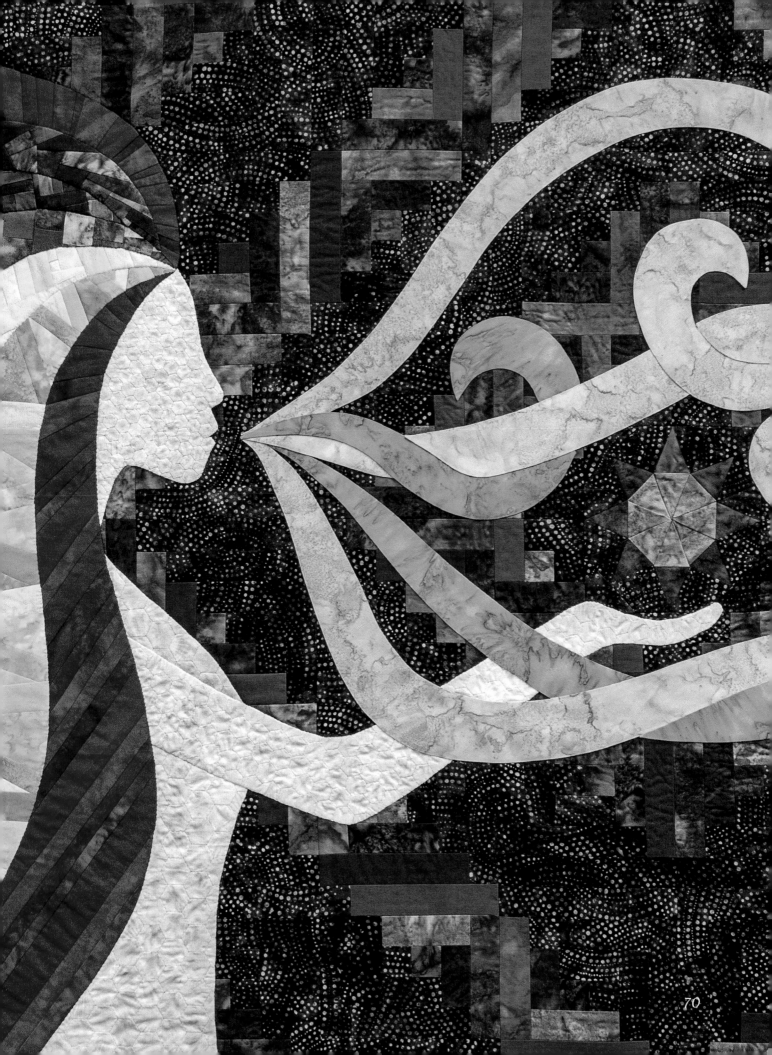

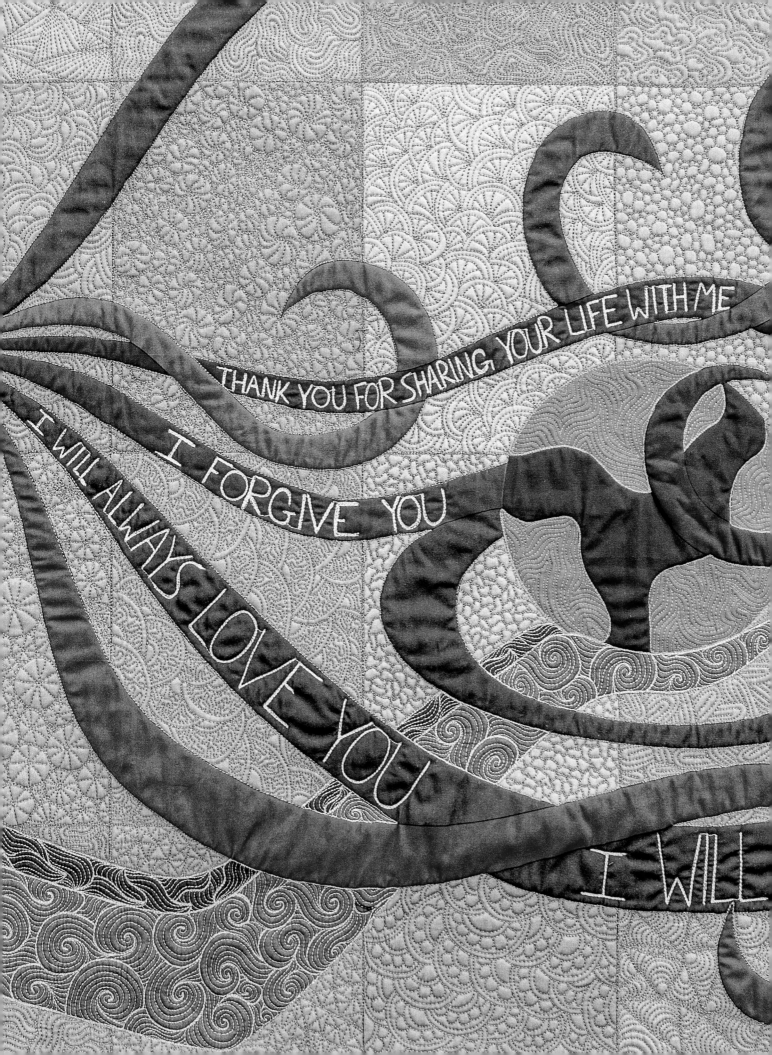

THANK YOU FOR SHARING YOUR LIFE WITH ME

I FORGIVE YOU

I WILL ALWAYS LOVE YOU

I WILL

It would take several more years, and more Express Your Love quilts for me to extend this acceptance and forgiveness to my mother.

When I'd cut her out of my life, I'd been convinced she simply didn't love me. If she'd loved me, she would have tried harder. She wouldn't have started drinking when I was eleven. She wouldn't have said so many hurtful things.

I had ten years of great memories before Mama started drinking. She'd been creative and energetic. In the evening, she'd pull out her hot glue gun and make craft projects. The smell of basket reeds soaking in water instantly takes me back to being five years old, watching her weave baskets at the kitchen table.

This split between who Mama had been and who she became was very painful. I couldn't understand her choices and felt only anger at her excuses.

But then James turned ten, and he began to change. My head spun with his new moods and flip-flopping attitudes. One second, we'd be hanging out and having a great time, the next second, he'd rage quit a game of chess and storm out of the room. It was even worse when he was hungry.

Suddenly I could understand Mama a bit better. Could this be why she started drinking? She didn't have just one child going through adolescence. She had three girls.

We were two years apart so at one point, we were seventeen, fifteen, and thirteen. I could only imagine what it was like to come home from a long day of work to be confronted with three formerly sweet girls who had suddenly morphed into monsters.

When I thought about it that way, I could understand. I could see how a glass of wine in the evening helped take the edge off the pain.

Because it hurts.

I couldn't understand this when I was fifteen, or twenty, or even thirty. It took my son beginning adolescence to truly understand what it was like to watch a child you love and know better than anyone in the world suddenly become completely unpredictable.

I finally accepted that Mama had been doing her best too. I forgave her imperfection. I released my anger and judgment of how things should have gone and found a well of compassion and empathy for her that I'd never felt before.

The original inspiration for this goddess had been to express love to my family, and that is exactly what she helped me do. But first, I had to learn how to forgive myself. I had to confront all the mistakes I'd made in the past and decide to love myself anyway.

I built this skill by sitting and stitching each of these broken quilts. I had to piece those four hundred hexagons and figure out how to finish that wild appliqué. I had to commit to seeing each quilt through to the end.

As I finished them, I forgave the bad choices I'd made in the past. I'd made many mistakes, but I'd also made five gorgeous quilts.

Express Your Love taught me that forgiveness wasn't a single step or a single decision. It was a slow, stitch by stitch process.

It's a choice to let go of painful memories. It's a choice to focus on the present moment rather than the past. It's a choice to express my love to my family and appreciate the time we have together.

I choose forgiveness.

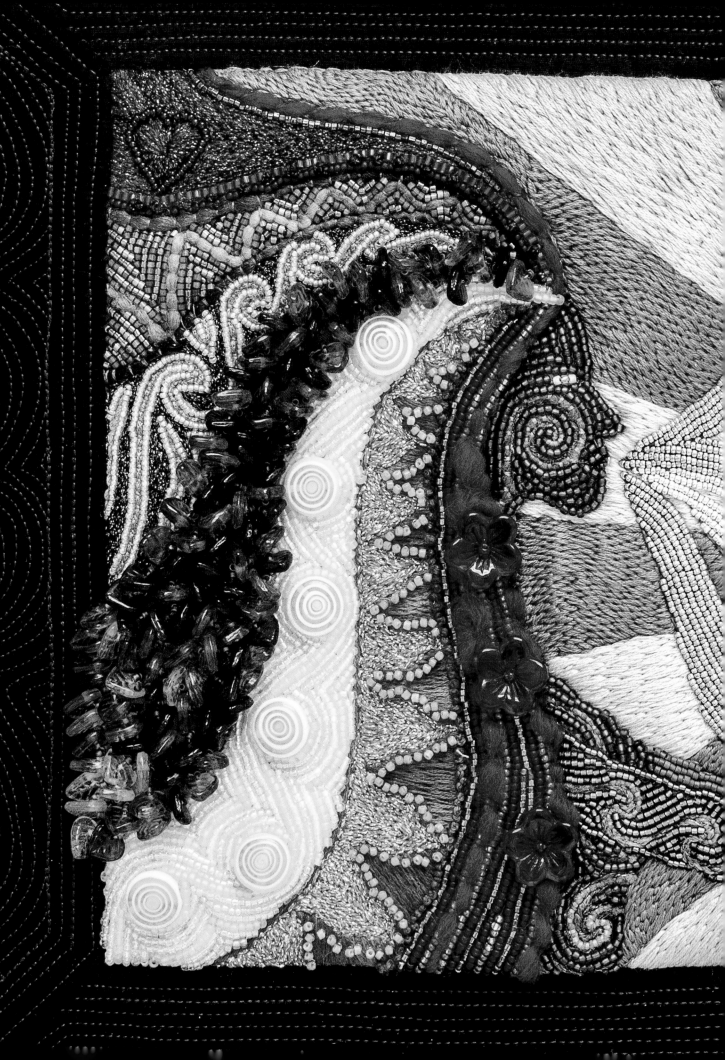

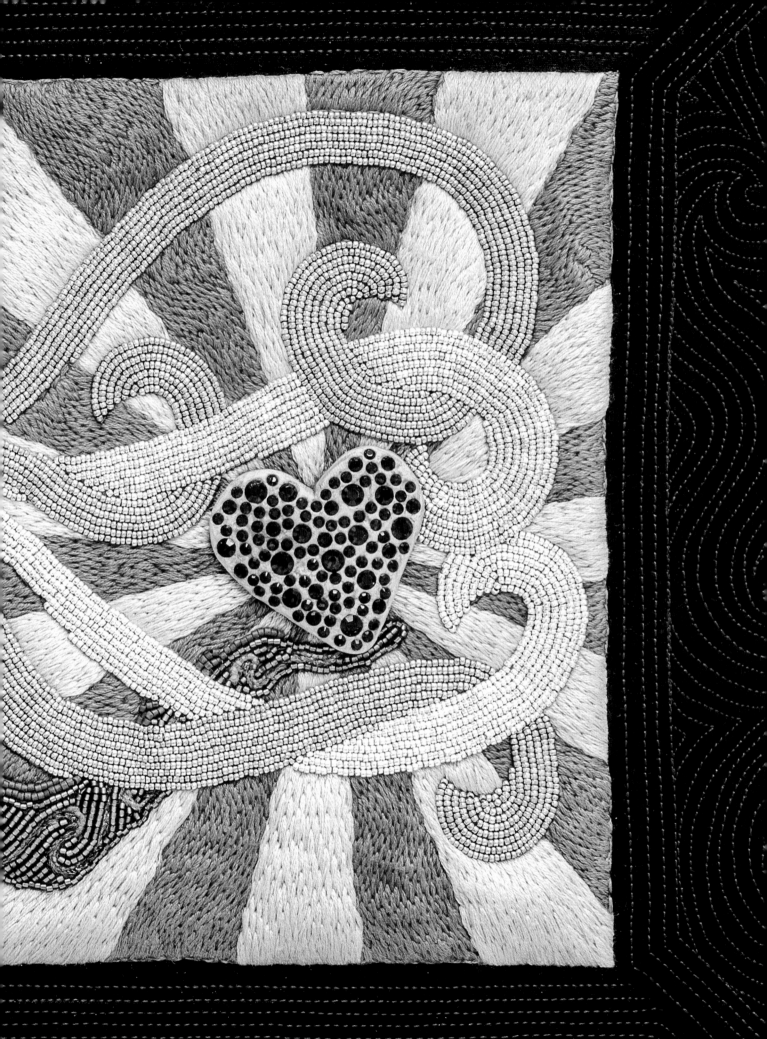

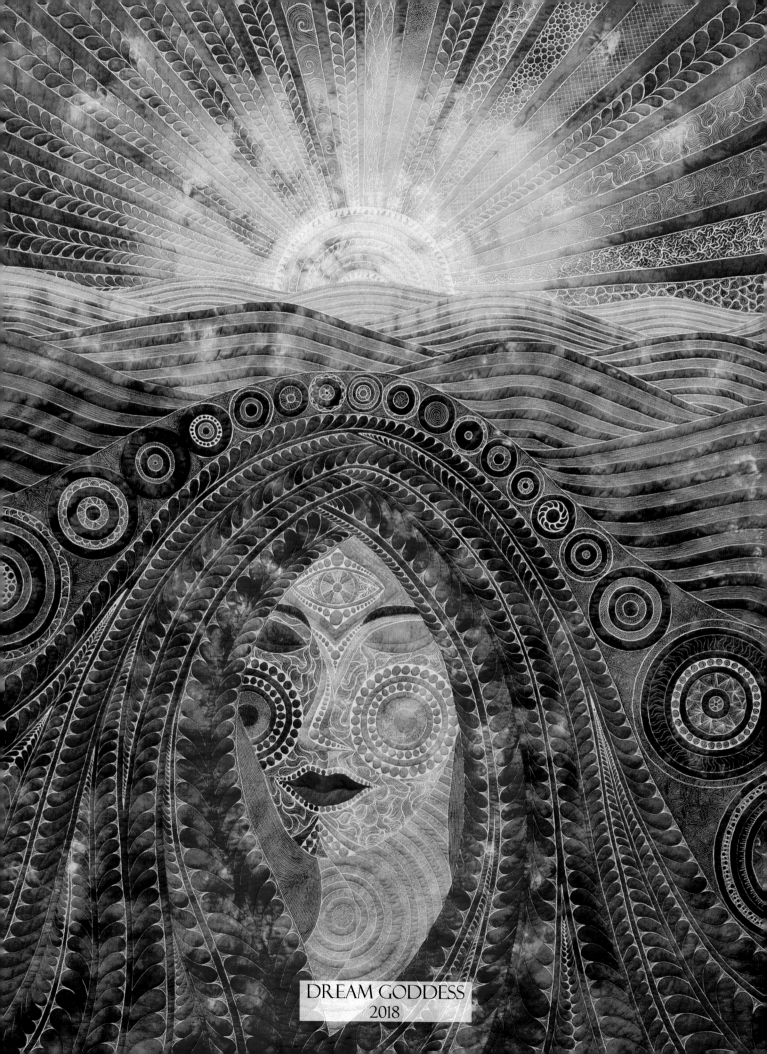

DREAM GODDESS
2018

COURAGE

Over the years, I've gone through phases of drawing in the morning, sometimes in the evening. I've journaled erratically the same way. A few years ago I started keeping a sketch pad next to my bed. Something about that sleepy time seemed to make ideas flow easier.

One evening, I sketched this goddess's peaceful face. I wrote, "What are you dreaming of?" on the corner of the page because it looked like she was asleep.

The next evening I sketched the landscape above her hair and the rising sun. It was perfect. I'd never had a design come together so easily. I knew this would be a powerful goddess quilt because even as a sketch, she made me ask:

What are you dreaming of? What do you want?

At first my answers were simple: I want to make beautiful things. I want to enjoy my life more. I want to take a trip with Josh.

My dreams seemed perfectly in line with the life I'd built. But underneath these smaller wants were much bigger desires. When I looked at Dream Goddess, I felt a shiver of fear.

Deep down, I knew my life could be more creative, more meaningful, and more fun. But only if I had the courage to change.

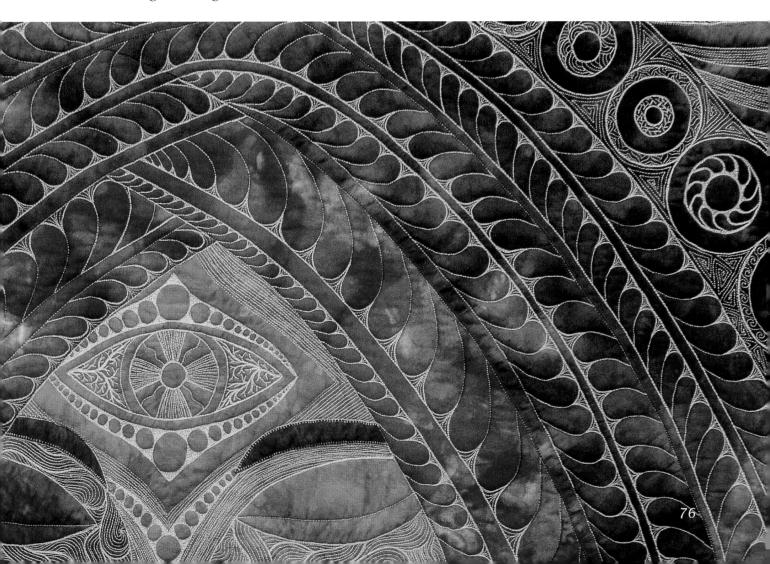

Around this time my dad started working for us. He prepared fabric and pieced quilt tops for my tutorials. Suddenly I had to get organized and learn how to share my quilting studio with another person. I couldn't leave a mess strewn over the cutting table for weeks on end. I had to focus on what we were making and have a plan for Dad each morning.

But this was a problem because it cut into my gaming time.

In 2015 I started playing a silly video game on my tablet. Every day I got rewards for "checking in" and playing certain levels. Even better, those levels could be played on autopilot. The characters could fight by themselves until they died or ran out of energy.

It became a multitasking nightmare. I set up the game next to my sewing machine and played while I quilted. I played while I wrote blog posts and edited videos. I played during family time and often instead of making dinner.

I downplayed the distraction. I had just enough focus to write a blog post or edit a video and play the game at the same time, so long as no one interrupted me.

But the level of concentration required was intense. Whenever I quit playing, it always felt like emerging from deep water. A thick fog clouded my mind and I had trouble concentrating.

This continued for over a year. My journal entries from this time were filled with frustration. I wanted to write a fiction novel and more books about quilting, but I was too disorganized to start these projects. I managed to make the minimum number of videos to keep our quilt along going, but it was always a struggle. I couldn't focus.

Soon the only time I felt relaxed and happy was when I was playing the game. It silenced the voice of motivation in my mind that was screaming in protest. No matter what my intention was first thing in the morning, no matter what I put on my to-do list, I always ended up wasting hours on that game.

The turning point finally came when Dad and I were preparing fabric for several projects at once. We were very busy and one day I simply forgot to play.

I launched the game the next day and found I'd also missed the start of a special event. *No! It's ruined!* I berated myself. *You won't get all the special things now!* I felt ridiculously guilty.

Something about this level of regret caught my attention. I calmed down and stared at the tablet in my hands. *This is a game,* I thought. *It's supposed to be fun. Why am I feeling this bad for not playing a game?*

The answer was very hard to swallow. I was addicted. I hadn't checked in and didn't get my 'fix.' The moment I realized this, I was disgusted. How long had that game been sabotaging my focus? How many things had I given up in order to play it?

Because deciding to turn on that game was also deciding *not* to work on Dream Goddess. I'd been hanging out in a virtual reality, beating levels and earning gold coins that meant absolutely nothing in the real world. I lost over a year of my life to that distraction. That was enough.

Quitting gaming changed everything. Suddenly I had a lot more time and made terrific progress quilting Dream Goddess. I also had more time to spend with my family. We enjoyed playing chess and board games and James and I would watch a silly show together every evening.

But within a few months, I noticed something else: I wasn't being very nice. I was often short tempered with Josh and snappish with James. My energy level was so low by the evening it was a struggle to keep my eyes open at the dinner table.

I started a food journal and recorded everything I ate and how I felt for a few weeks. It didn't take long to uncover the culprit – alcohol.

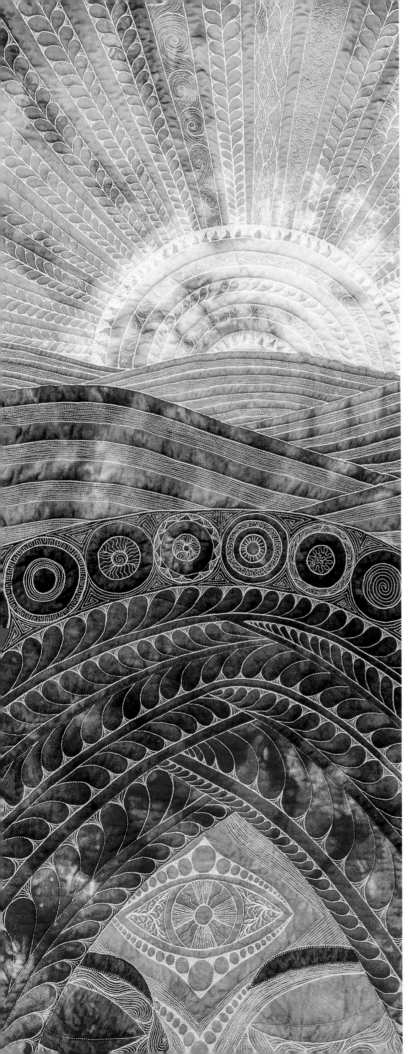

Josh and I had enjoyed drinking a beer with dinner since college. But over the years, a few beers had given way to multiple drinks before and after dinner. I'd slipped into the habit of always having a drink by my side: when I was watching TV, when I was writing a pattern, even when I was quilting.

I knew better. This was the same habit my mother had slipped into and I'd fallen into the exact same trap.

I cut back and immediately noticed a difference. I felt more awake and alert. I hadn't realized how much even one glass of wine had been affecting my mood. I'd often say things I'd normally keep to myself, and my temper had a much shorter fuse.

But cutting back was very difficult. I didn't think I was an alcoholic, but I found myself making excuses for a third or fourth drink, especially when we were out at restaurants. Everyone else had a drink and I felt itchy and freakish to not join in.

Around this time I'd taken a break on quilting Dream Goddess and had hung her up in the living room. I stared at the quilt and a new question arose from my heart:

If I am building the life that I want, and this is truly the life of my dreams, why am I drinking?

This question cut through the fog of excuses and years of habit. I knew how much even one glass of scotch was affecting my mood and energy. I knew I wasn't a good person when I drank even one glass of wine.

Alcohol had become an impediment to my life. Just like video games, this habit was a means to escape and a distraction I didn't need.

I wanted to love my life and my family. I wanted to bravely pursue new goals. But I couldn't take a single step towards those dreams with a drink in my hand so I quit in January 2017.

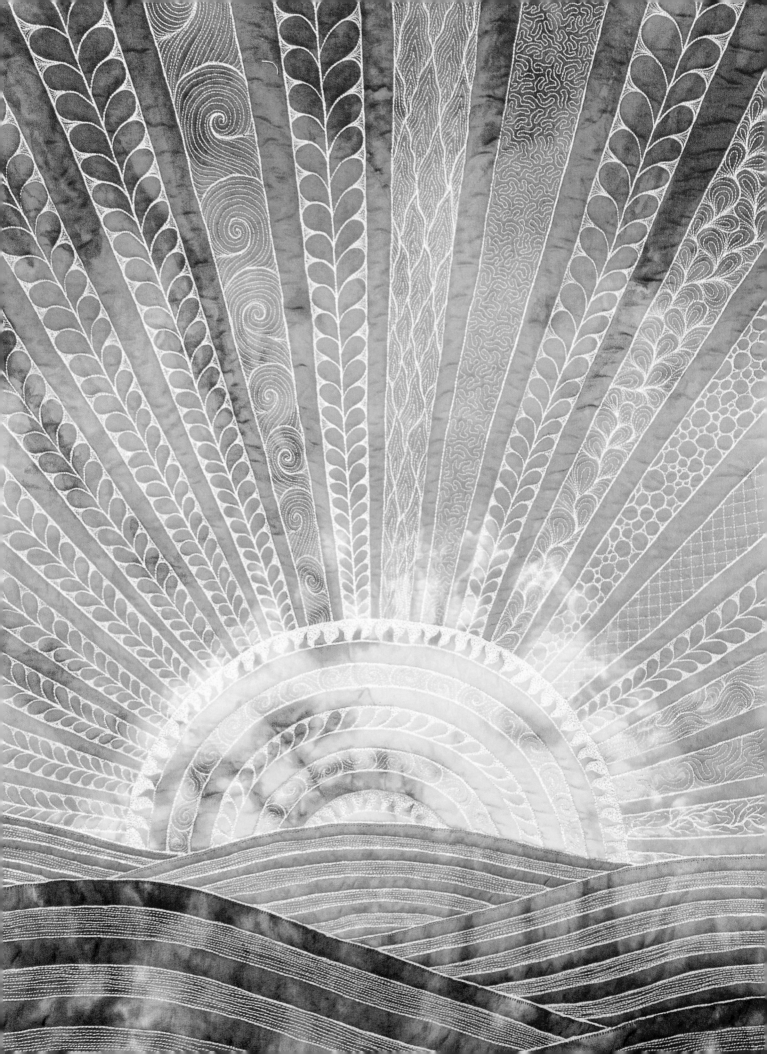

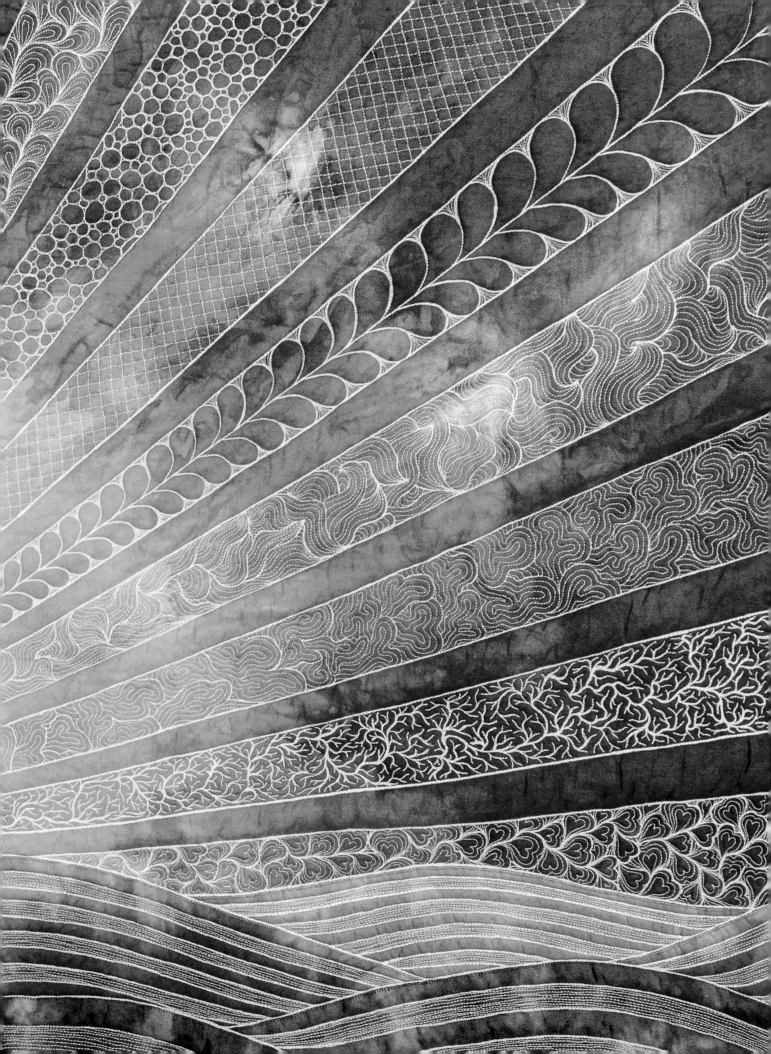

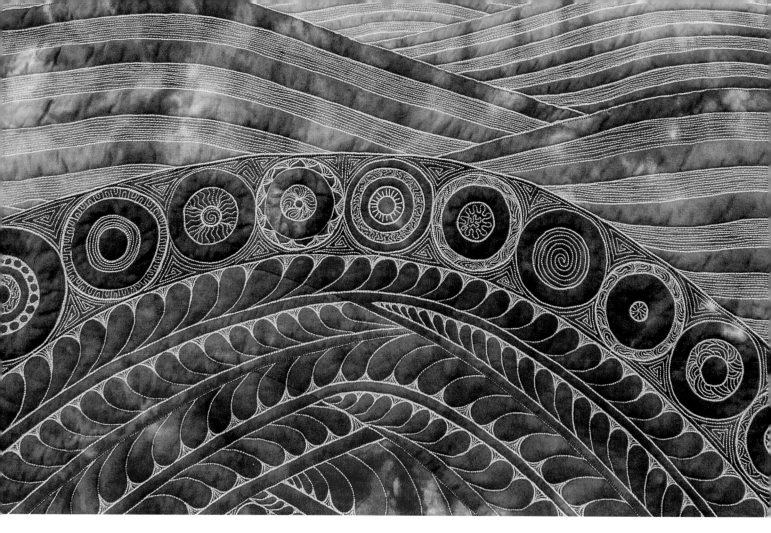

Quitting gaming gave me hours back every day to be more creative. Quitting drinking lifted the fog in my mind. I now had the space and time and focus to make things I'd been wanting to create for years.

I wrote a book about walking foot quilting, then I wrote my first fiction quilt novel, *Mally the Maker and the Queen in the Quilt*. I loved creating these books. They were challenging and different and I had to learn new skills: quilt photography, fiction writing and book illustration.

These accomplishments felt different from everything I'd made in the past. I'd wanted to write these books for years. It eased some tension in my heart to be following my inspiration and doing the work I most wanted to do.

I knew without a shadow of a doubt, I couldn't have created these books with gaming or alcohol in my life.

But even after I quit my bad habits, I had trouble finishing Dream Goddess. Part of the problem was the quilting design. I'd left a space open in the sky section of the quilt. Instead of filling each of the sun rays with feathers, as I'd designed, I decided to leave ten sections open so I could fill them with different free motion filler designs.

But when I reached this area, I couldn't decide which designs to quilt. I didn't want to make the wrong choice. I got stuck in fear and refused to make a decision.

Less than six hours of quilting time remained, but my refusal to make a simple decision on Dream Goddess doomed her to wait, folded in a closet, for three years.

I look back at this time and I know what I was really avoiding. I'd taken small steps towards the life I wanted. I'd written two books from my heart and I'd eliminated two poisonous habits that had been blocking my path for years.

But I was afraid if I finished Dream Goddess, I'd have to commit to my biggest dream: teaching and sharing my goddess quilts.

This was the secret goal of my heart. For years, I'd wanted to write *this* very book. I dreamed of designing fabrics featuring these powerful women and sharing these stories and inspiration more widely.

But in order to do this, I'd have to change.

I'd have to stop spending all my time designing traditional quilt alongs. I'd have to stop sharing beginner tutorials. I'd have to stop waffling around, piecing quilts anyone could design and focus on only the unique things I naturally make.

But I was still stuck in fear that my goddess quilts couldn't possibly be successful. I was too afraid to risk the life and business I'd built and fully commit to this goal. I was too scared to finish Dream Goddess.

CHOOSING COURAGE

In 2018, my word of the year was challenge. Almost from the first moment, challenge forced me to change. I couldn't put off my goals and dreams one second longer. It was time to pull on by big-girl panties and commit to making and teaching goddess quilts or abandon the inspiration forever.

Rise to the challenge of your life became my motto.

Thankfully I'd already broken two toxic habits. Before I quit, it was easy to think a single drink with dinner or a few minutes of video gaming wasn't a big deal.

It was easy to make excuses in the moment when I was only thinking about what I had to do that day.

But it was a big deal when I looked back at those years spent drinking and gaming and realized how very little I'd accomplished. The days may seem long, but the years they create are very short.

Life is also unpredictable. At the beginning of my year of challenge, one of my good friends got very sick. I tried my best to be supportive and upbeat.

I texted her silly pictures every week. I made her laugh and she told me later that was a welcome distraction during that scary time.

But her illness affected me too. I could no longer escape the reality of my mortality. Every day was precious and I didn't want to waste a single second of the time I had left.

I rose to the challenge of finishing Dream Goddess. I picked a handful of designs and quilted the final rays in the sky. As I finished this area, I realized the designs didn't really matter. Any design I picked would have been just as good as another.

The wrong choice had been refusing to decide.

Finishing Dream Goddess forced me to change. I had to cut out all distraction and get serious about pursuing the things my heart ached to create. I had to stop going through the motions and letting the days slip by. I had to rise to the challenge.

That question, *what are you dreaming of?* is surprisingly powerful.

It requires courage to answer honestly. Courage to be open to change. Courage to focus and commit to doing the work that must be done.

I choose courage and I will continually ask and honestly answer this question for the rest of my life.

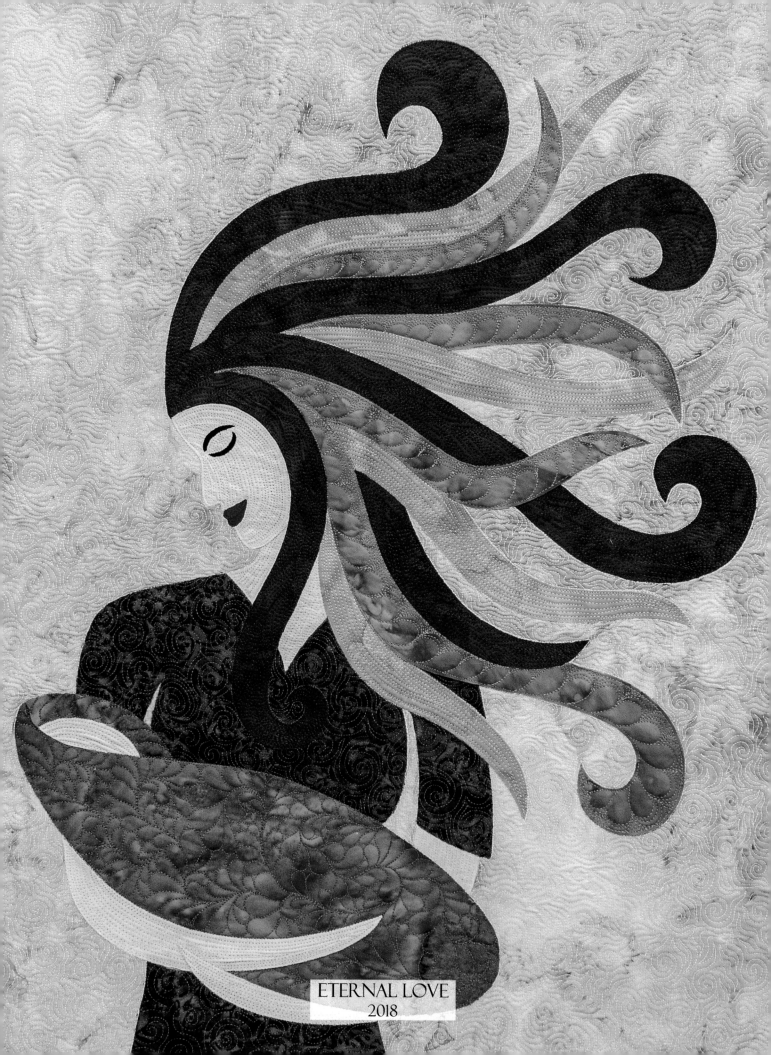

ETERNAL LOVE
2018

ACCEPTANCE

Challenge guided me through 2018 and I followed wherever it led. When I noticed a three month space in my video schedule, I decided to create a mini quilt along to fill in the gap.

It would've been so easy to throw together some traditional quilt blocks and make a table runner or seasonal throw quilt. But I was done with easy. I was ready to accept the challenge of sharing a goddess quilt. I did it right this time with a detailed quilt pattern and step-by-step videos and Eternal Love was a great success.

During the quilt along someone asked, "Is there something you're trying to tell us, Leah?"

I had no idea what she was talking about. Then I realized she was asking if I was pregnant. Heck no!

After James was born, Josh and I had firmly decided we were a one-kid family. We'd slammed that baby door shut, locked it with a dozen padlocks, dropped a bar over the front, and buried it in twelve feet of concrete. We were NOT having more kids, thank you very much.

I mentioned that comment to Josh as a joke. It seemed ridiculous to think about getting pregnant the same year James was entering middle school.

But Josh didn't laugh. He said, "That wouldn't be so bad. I miss James being little."

I did a double take, "Wait, WHAT? You want more kids?"

Suddenly that baby door I thought we'd shut so firmly blew wide open.

A million questions hit me at once. Can we have more kids? What would that be like, to be a new mom all over again, right now? How would this work with the business and a middle schooler and everything else?

I couldn't wrap my head around it. It seemed too scary and risky and not part of our plans. I made a concerted effort to talk Josh out of having another baby.

"What if we have an extrovert? We'll never shut her up! What if he's super fussy and colicky? We have such a great thing going with James. We're not gamblers - this is taking a huge gamble with our lives!"

When I put it that way, Josh agreed. He let it go and seemed fine with shutting that baby door once again.

But I couldn't stop thinking about it. I remembered James as a baby and the long days of breastfeeding and changing little diapers and crossing my fingers he'd sleep through the night. I'd missed a good chunk of that time to distraction, worry, and postpartum depression.

I suddenly realized how much I missed the gap-toothed smiles and chubby arms held out for hugs. I missed being the one he ran to when he was hurt.

A hopeful voice in my heart whispered, "It will be different this time. It will be so much better."

I laughed at myself. Seriously, this made me chuckle. Better? No, having a baby will be WORK. It will be distracting and messy and frustrating beyond belief!

But it would also be wonderful.

One morning I grabbed a piece of paper while drinking my cup of coffee. I opened myself to any inspiration and in less than five minutes, I sketched a simple pregnant goddess.

I'd been thinking about the exhaustion of pregnancy, and how I'd hated feeling so tired when I carried James. Back then I couldn't appreciate just how short that time would be. I hadn't realized how precious and sacred pregnancy was until the moment I was giving birth.

I sketched the goddess's hair swirling around her large belly. I added more lines until she was tucked into an eye-shaped pocket and that became her name: Eye of Calm.

The process was so easy, I didn't erase a single line. I knew then that I'd been blocking my greatest inspiration for years.

James' birth had rocked my world. I'd glimpsed Heaven that day and every cell of my being had been turn inside out. Why hadn't I captured that moment, that most crucial, life-changing moment in fabric and thread?

I'd been too scared. I had run from that inspiration. I didn't want to share my birth story in all its messiness and shame.

I'd shut down the idea of having more children so completely, I refused to even draw the most powerful figure a woman can have - when her body is filled to the brim with new life.

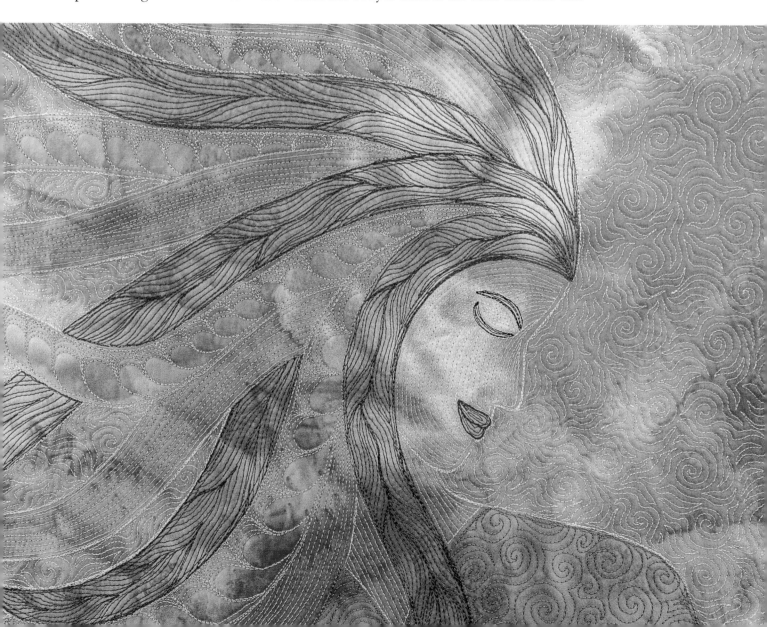

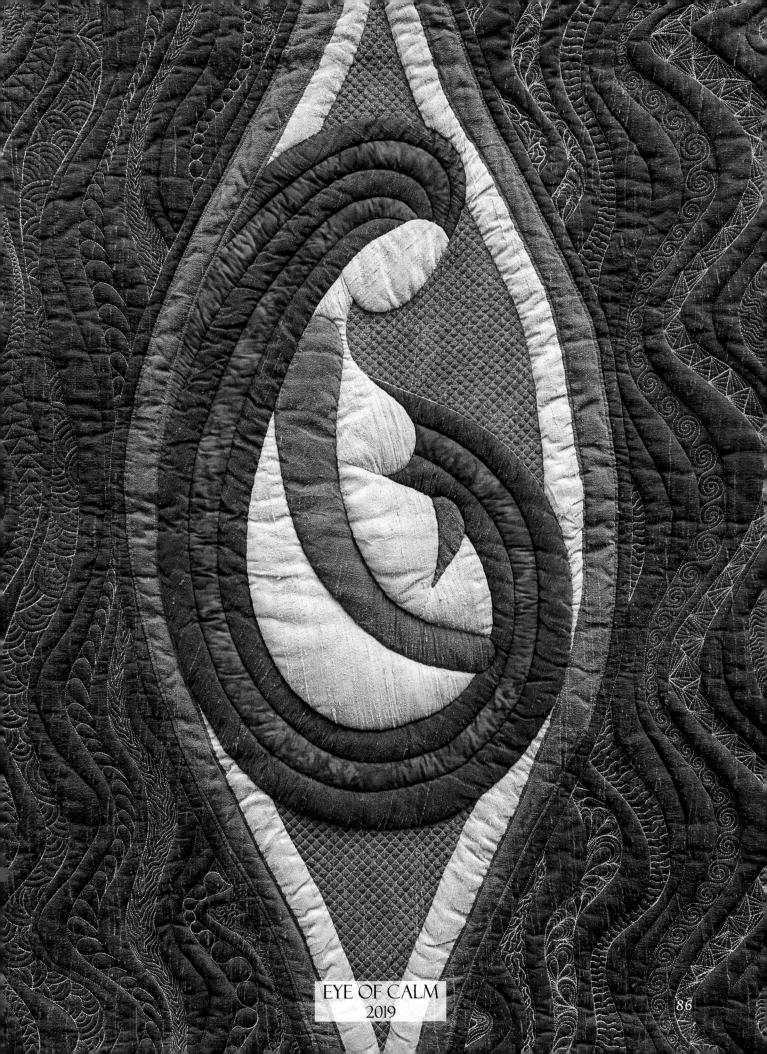

EYE OF CALM
2019

86

But still I wondered, could we have more kids? Should we try for this?

It scared me too much to answer these questions. I was afraid I was too old. I didn't know if we could support another baby. I was afraid we'd need a bigger house, bigger car, bigger everything.

Then I had an experience in October 2018 that forever changed the way I looked at money and family and space and need.

Hart Square is the largest collection of historically preserved log cabins in the United States. Bob Hart began collecting these cabins from Catawba County, North Carolina in the 1970s and built a village of them on his land. This magical place is located less than one hour from my home.

Once a year, on the last Saturday in October, the village comes alive with a huge festival. Potters, gunsmiths, quilters, weavers, spinners, printers, and reenactors all gather to demonstrate what life was like over one hundred-seventy years ago. That year, I was one of them.

I spent an entire day in a log cabin originally built in 1840, hand quilting on a red and white Double Irish Chain.

Magical doesn't come close to describing this experience. It was like traveling back in time. The fire burning in a rock fireplace across the room was the only source of heat. A single light shone over the quilting frame where I sat and stitched and shared in a gentle conversation with four women I'd just met.

A burden lifted off my shoulders that day at Hart Square. As I gazed around that low ceiling cabin I realized this was all a family needed. A kitchen stove, a fireplace, a bed, and a quilting frame.

There was no central heat. There was no running water. There was no electricity, but a family raised ten children in that log cabin.

This experience gave me so much appreciation for everything I had. I didn't need anything else. I had so much in comparison to my ancestors: knowledge, sewing machines, central heat, and great lighting.

If my great, great grandmothers could raise multiple children in a log cabin like that, I could absolutely rise to the challenge of having another baby. Maybe even two!

I shared my new perspective with Josh. Turns out, I hadn't really changed his mind. He wanted another child as badly as I did. Even James was excited and supportive. He'd always wanted a baby brother.

We were very optimistic. I'd gotten pregnant so quickly with James, it had been a walk in the park. I'd also been twenty-two years old.

Months slipped by and no baby came. Darn those storks and their finicky flight patterns!

Making Eye of Calm was exactly what I needed during this time. This quilt gave me permission to think about pregnancy every day.

She also kept my hands busy while I worked through my disappointment each month.

I wanted a new baby badly now and I wasn't sure if it was going to work out.

Slowly hand stitching this quilt top helped me nurture a seed of hope and silence the fear that we'd waited too long.

I constructed the quilt out of special dupoini silks I'd saved for years. Unfortunately this fabric didn't behave itself well and distorted noticeably over the goddess's belly.

I knew if I quilted over that area densely, it would form ugly pleats and probably distort the fabric even more.

So I decided to do the opposite. I stuffed the belly with another layer of fluffy batting, making it extra puffy.

This pregnant goddess really looked pregnant! It was the perfect way to sort out that fabric issue and make the quilt even more dramatic.

I spent several weeks considering the quilting design. In truth, I was stalling, hoping to get pregnant before I moved to the next step.

As the days slipped by, I realized I was being silly. I might never get pregnant again!

I didn't want an unfinished quilt floating around my sewing room to remind me of that.

It was time to get to work.

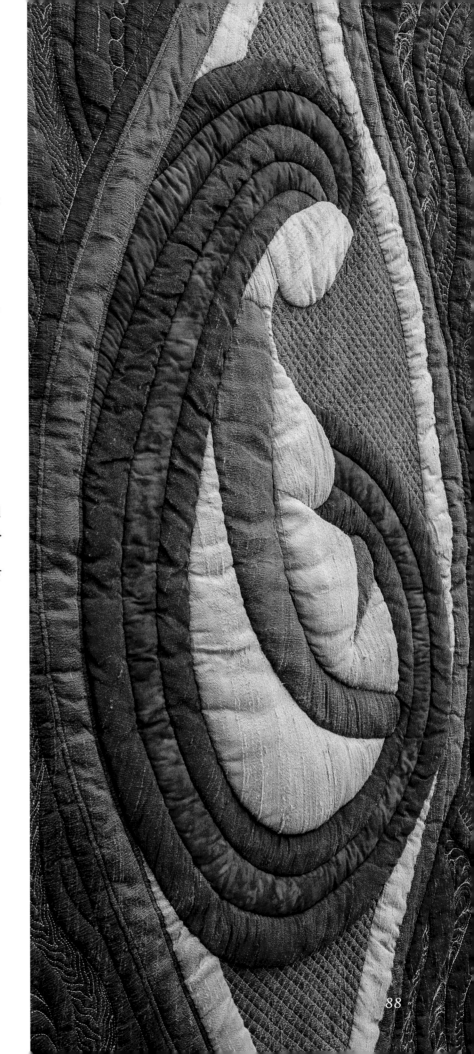

Unfortunately, as soon as I threaded my machine, perfectionism wound around my spool spindle too.

That stitch is too big. Rip it out. I stitched off the line. Rip it out. The stitching veered away from the appliqué. Rip it out. On and on it went. Two stitches forward, one stitch back.

Around this time, I began writing this book and I dug out a box of journals I'd written more than ten years ago. I didn't like what I found.

Page after page was filled with frustration and anger. For years I'd wanted to stop being such a perfectionist. I'd been sick of stitching my quilts to death for a very long time.

I brought this up with my therapist, Jane, who had been helping me by this point for six years. She knew me very well. I asked why I seem to be living in a loop. Why are so many of my journal entries nearly identical, but several years apart? I worried that deep down I was just a perpetually unhappy, angry person.

"No, Leah, you're not an angry person. You're just stuck," she explained. "You're stuck in a place emotionally by a single thought – that you are unworthy. You're trying to fix that by working so hard, by quilting your quilts like crazy, but all of that is external. It's never going to fix the thought patterns in your mind. It just makes it worse."

Jane was right. Every time I ripped out stitches, the thought in my head was, "This isn't good enough. I must make it better."

The feeling behind that thought, the one driving my hand to pick up the seam ripper in the first place was fear. *If I leave this ugly stitch in this quilt, someone else might see it. I'm afraid if they see that ugly stitch, they will see I'm ugly too. They will see how unworthy I am.*

After all this work, after making so many beautiful goddess quilts, stitching out so many issues into fabric and thread and years of therapy, why was this still an issue?

Jane shrugged. "Like I said, you're stuck. You have got to challenge that thought that you aren't good enough, that the things you make are not good enough. And you must challenge it again and again, every time it comes up. Only then will things start to change."

That meant actively resisting the urge to rip stitches. It also meant resisting the urge to "throw more thread at it" and cover up errors. I had to stop obsessing, stop ripping, and stop trying to hide my mistakes.

CHOOSING ACCEPTANCE

In the past, I'd only been willing to accept imperfection in my quilts after exhausting myself. But leaving in imperfect stitches when I was completely spent didn't count. I wasn't actively challenging the thoughts and feelings behind my compulsion to rip or over-stitch.

When I'd reached that point of shrugging my shoulders at mistakes in the past, I just didn't care.

That's what made Eye of Calm different. I wasn't exhausted. I hadn't beaten myself down for weeks. I'd recognized ripping was a problem at the very beginning. I took a break. I decided when I returned to the quilt, I would not rip any stitches or try to hide my mistakes. Every error would show, and this was very difficult.

When I made a mistake, it was like an electric shock ran down my spine. *No!* Almost before I'd acknowledged the thought, my hands were pulling the quilt away from the machine and rushing to pick out the offending stitches.

Challenging this perfection drive required me to slow down. I had to feel that electric shock, but NOT touch the quilt. I had to sit with the screaming thoughts in my mind, "Oh my gosh, look at that terrible stitch! What did you just do? That looks AWFUL! I HATE IT! You SUCK! Rip it out! Rip it out! RIP IT OUT RIGHT NOW!"

I resisted, but it was very hard. I'd pick up my seam ripper only to put it back down again. I'd start thread painting over a line to cover a mistake and have to take my hands off the quilt for a minute to stop. I started talking to myself, just to dial back the anxiety. "It's okay. It's not that bad. It's good enough."

Those words were very hard for me. I wanted it to be PERFECT. I wanted the immaculate stitching on that quilt to flow effortlessly from my hands. I hated the idea of leaving even one mistake in my quilts. But that was an impossible goal. I had to accept and be satisfied with it being good enough.

Quilting Eye of Calm became a practice of acceptance. After several stressful evenings, I found new words to help me resist the urge to rip. *It's good enough. I like it like that. I like it the way it is. That's just fine.*

This became a mantra of sorts. Over and over I'd repeat these words whenever I made a mistake. I still felt that electric shock. I still stopped and glared at my stitches, but slowly, challenging that urge to rip felt easier. *I like it like that. It's good enough.*

I had to repeat these words of acceptance over and over. In a way, this was also a practice of forgiveness. With each mistake, I had to forgive my imperfection, accept my ability for what it was and keep moving forward.

In another way, this was also a practice of self love. As I quilted, these words naturally flowed from my heart: "I am good enough. I don't need this to be perfect. I don't have to be perfect. I like who I am. I'm just fine."

This practice will not end with Eye of Calm. I must continue this with every quilt I make or it will be far too easy to slip back into my old habits of judgment and perfectionism.

I choose acceptance for who I am, what I can create, and all my limitations. I am good enough.

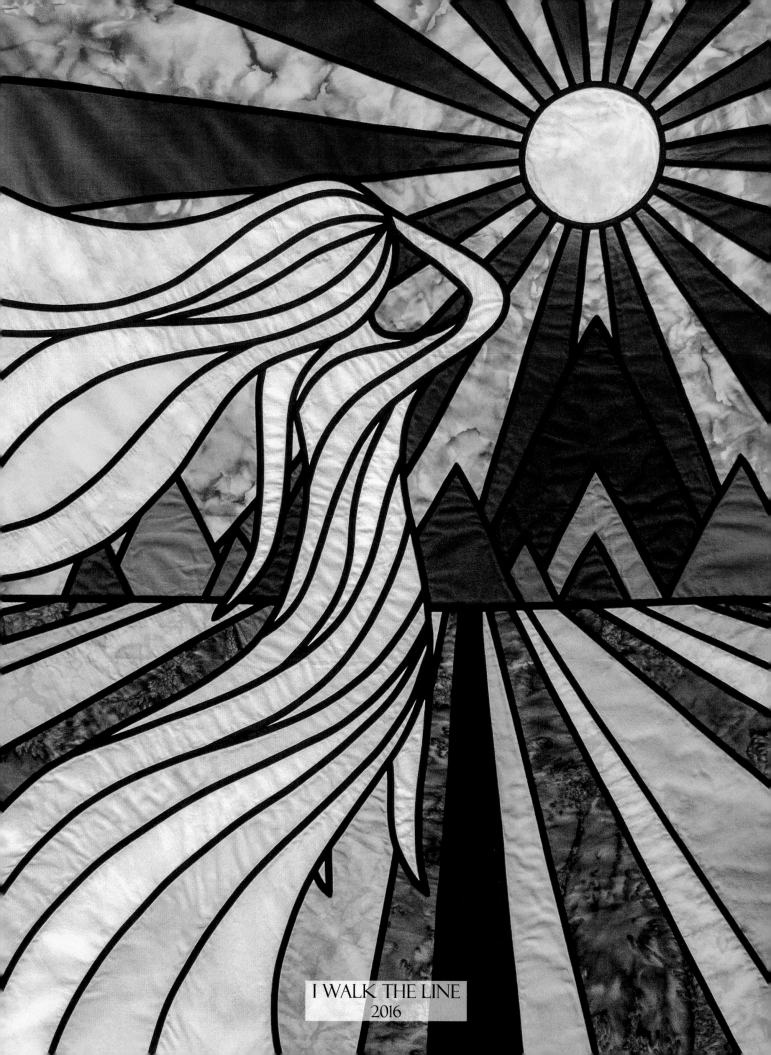

I WALK THE LINE
2016

THE PATH FORWARD

Making goddess quilts has changed my life. They are not just pretty wall hangings. Every single one has taught me lessons I couldn't have learned anywhere else.

When I look at these quilts, even years after I finished them, they still pull at my heart and push at my mind. They make me stop and ask questions. *What are you dreaming of? Are you focusing on the right thoughts? What can you do to release your light today?*

These powerful women continually remind me to live a life filled with gratitude, acceptance, and forgiveness. They help me keep my fear, negativity, ego, past pain, and perfectionism in check.

They help me walk the line.

A few months ago, I shared a bad dream with my dad in which I somehow managed to cut off both my arms with the radial arm saw in my wood shop.

Dad shook his head and said, "Leah, you have a darkness in your mind you've gotta learn to resist. Keep it light, girl. Focus on the light."

Those words stuck with me.

Focus on the light.

This is my one piece of advice for you, if you decide to make a goddess quilt: Focus on the light.

Focus on being open to change. Focus on expressing your creativity. Focus on thanking God for all the blessings you have.

Focus on the positive thoughts in your mind. Focus on releasing hurt and forgiving the past.

Focus on loving yourself with joyful abandon. Focus on living without fear or regret. Focus on all the things you don't know and the journey yet to come. Focus on the life you dream of creating. Focus on opening doors you thought were closed forever.

Focus on committing to your highest potential. Focus on the courage to change and becoming the person you wish to be. Focus on acceptance for all that you cannot change. Focus on the light.

All paths of self discovery can lead in two directions. From my experience walking this path myself, I can promise you this: if you go looking for pain, you will find it in excess. Please don't go there.

Focus on the light.

Focus on being good enough, and accepting and forgiving your flawed, imperfect self. We are human beings with human hands. Our quilts will have flaws.

I know how hard it is to want to make something match the picture in your head, but no matter how hard you try, it just doesn't look the way it should.

You'll have to decide, just like I did, that it's good enough. You like it like that. It's just fine.

And that you are good enough too.

Let's go quilt,

Leah Day

ABOUT THE AUTHOR

Leah Day is an award winning quilter, online teacher, and author. She is the creator of the Free Motion Quilting Project (FreeMotionProject.com), a blog where she has shared new quilting tutorials every week since 2009.

Leah's mission is to empower and encourage quilters of all skill levels to make beautiful quilts. Her helpful quilting videos and classes have been viewed over eighteen million times by quilters from around the world.

Leah is the author of Explore Walking Foot Quilting, a beginner quilting guide, and 365 Free Motion Quilting Designs, the largest collection of machine quilting designs ever published.

She's also the author of Mally the Maker and the Queen in the Quilt, a fantasy story about a little girl who goes on an adventure in a magical quilt world, and Dream Goddess, a three month planner and creativity journal.

Leah's primary craft is quilting, but she also enjoys knitting, crochet, spinning, and wood turning. She lives in North Carolina with her family, a flock of chickens, herd of bunnies, two cats, and one lazy dog.

Learn more at LeahDay.com